IMAGES
of America

MOHONK
MOUNTAIN HOUSE
AND PRESERVE

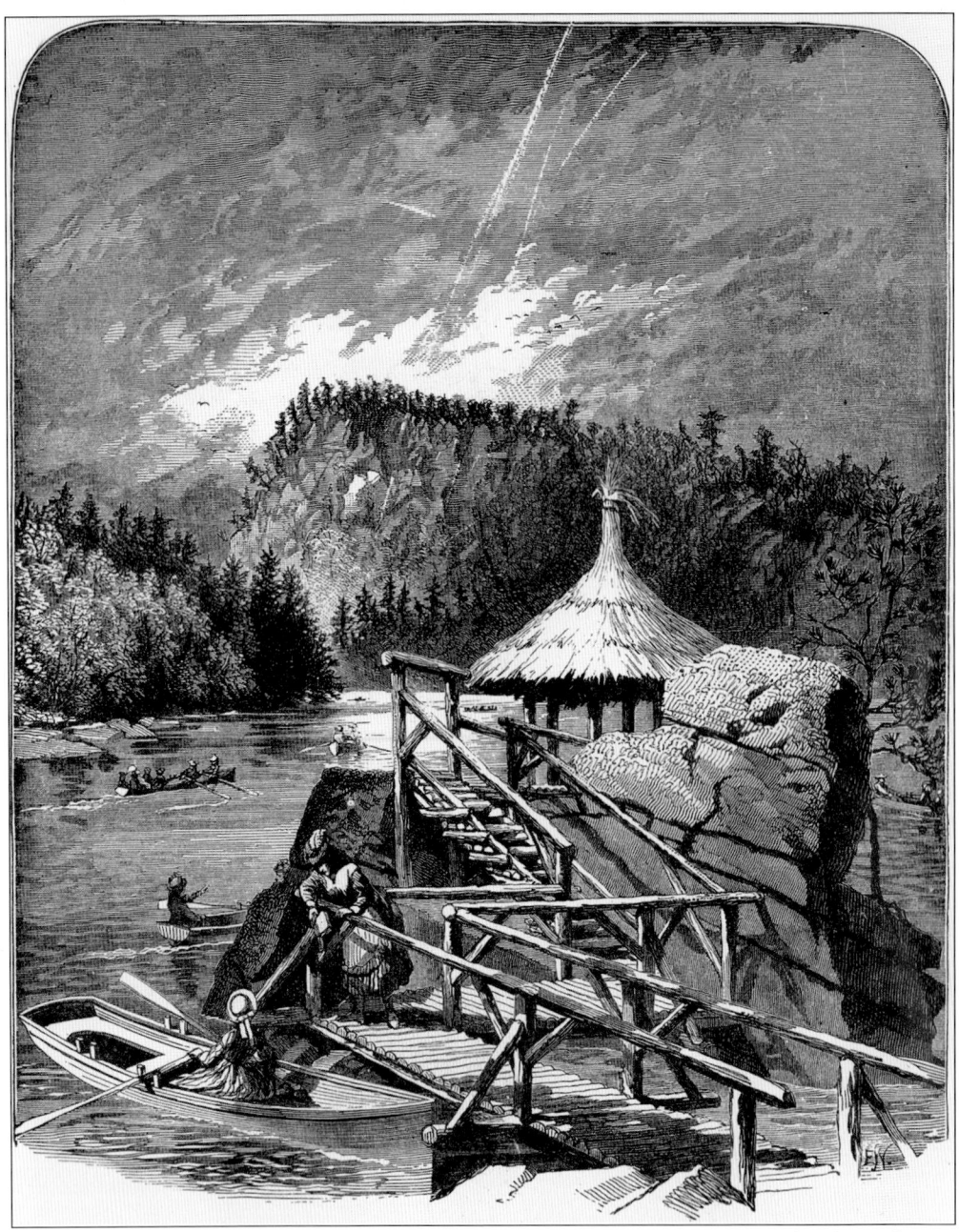

"Few spots on our continent unite so much beauty of scenery, both grand and lovely, within so small a compass, to be enjoyed with so much ease," wrote Arnold Guyot in 1887 after a visit to Mohonk. Guyot was a professor of geography and geology at Princeton University. (Engraving by E.J. Whitney/Courtesy of MMHA.)

IMAGES *of America*

MOHONK MOUNTAIN HOUSE AND PRESERVE

Robi Josephson

Copyright © 2002 by Robi Josephson
ISBN 978-0-7385-1104-7

Published by Arcadia Publishing
Charleston, South Carolina

Printed in the United States of America

Library of Congress Catalog Card Number: 2002108543

For all general information contact Arcadia Publishing at:
Telephone 843-853-2070
Fax 843-853-0044
E-mail sales@arcadiapublishing.com
For customer service and orders:
Toll-Free 1-888-313-2665

Visit us on the Internet at www.arcadiapublishing.com

On the cover: Visitors crowd into a rustic gazebo on Sky Top Path c. 1895. Mohonk Lake and Mohonk Mountain House are below them, with the Rondout Valley and Catskill Mountains in the distance. (Photograph by M.J. Buckin/Courtesy of MMHA.)

Contents

Introduction		7
1.	Beginnings: Up to 1869	9
2.	A Mountain Haven Is Born: 1870–1899	17
3.	Growth in the New Century: 1900–1929	37
4.	Daily Life on the Mountain: 1930–1959	63
5.	A New Era of Conservation: 1960–1989	85
6.	A Continuing Commitment: 1990–Today	103
Acknowledgments		127
Selected Bibliography		128

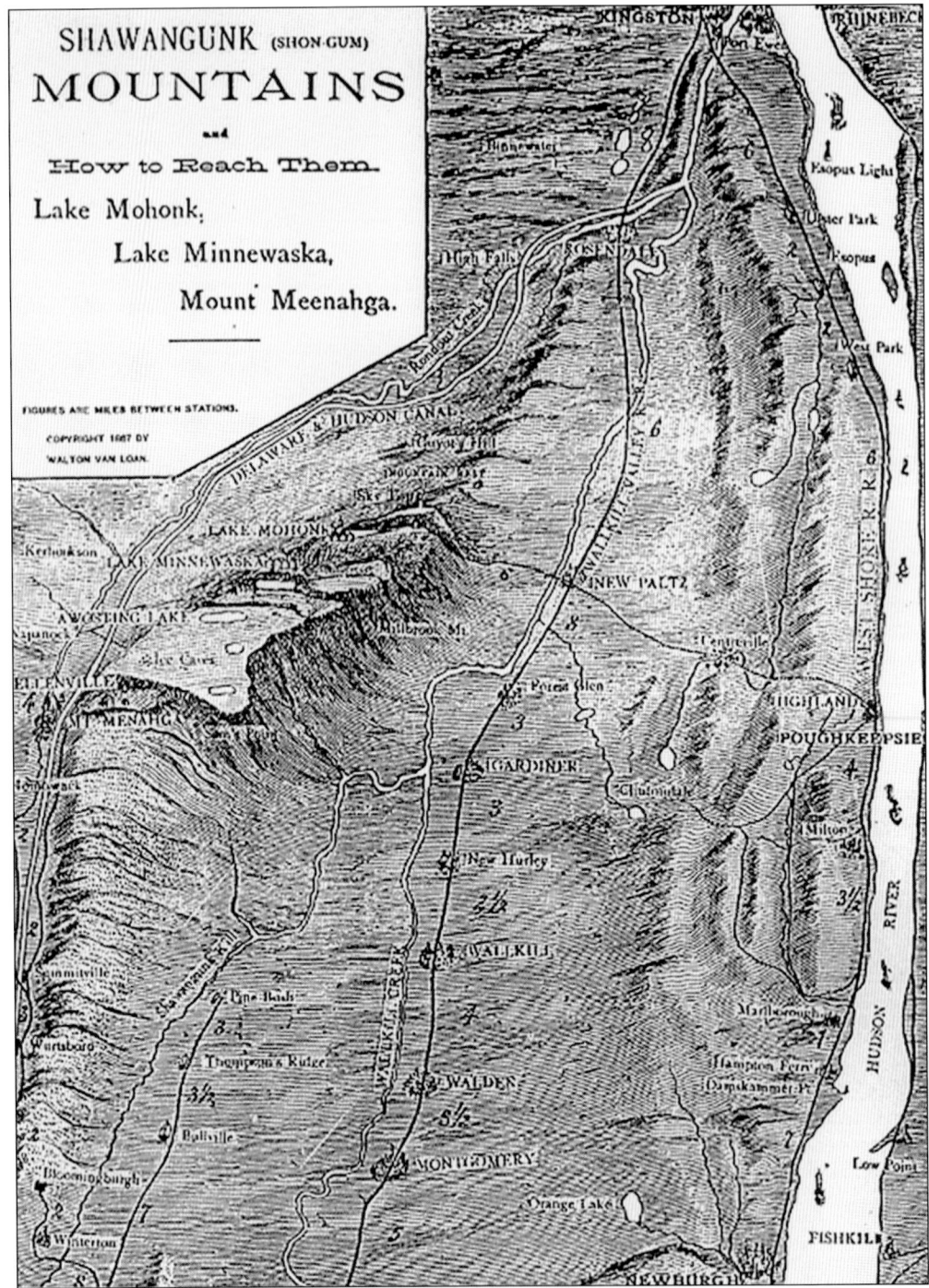

Lake Mohonk was the northernmost destination for those traveling to the Shawangunk Mountains during the late 1800s. Routes available to guests at this time, from left to right, were the Delaware and Hudson Canal, the Wallkill Valley Railroad, and the West Shore Railroad. This 1887 map by Walton Van Loan, known for his Catskill guidebooks, appeared in early Mohonk Mountain House brochures. (Courtesy of MMHA.)

INTRODUCTION

Mohonk: Mountain House and Preserve focuses on the human history of two places of remarkable beauty in the Shawangunk Mountains of Ulster County, New York: Mohonk Mountain House, a 251-room hotel located at Mohonk Lake, and the Mohonk Preserve, a bordering yet independent nature preserve. The Shawangunks (pronounced "shon-gums") are a series of parallel ridges midway between the Hudson River and Catskill Mountains in southeastern New York State. Beginning at the tri-state corner of New York, New Jersey, and Pennsylvania, the range stretches northeast for about 50 miles until it ends at the town of Rosendale, a few miles north of Mohonk Lake. From the air—as well as in E.J. Whitney's engraving opposite—the Shawangunks resemble the neck and head of a graceful bird.

Mohonk Lake is the most northern of the five Shawangunk "sky lakes," so designated because they are fed only by precipitation. These lakes were sculpted during the last Ice Age, when mile-high glaciers wrenched existing fissures apart during their great push southward. Mohonk Lake is 1,247 feet above sea level. The highest point in the Shawangunks rises only another 1,000 feet. This relatively low range has an ancient and complicated geology of folding, faulting, and fragmentation. The resulting topography, with distinctive lakes and cliffs, has played an integral role in the cultural history of the Shawangunks.

Two themes are developed in this book: the changing ways in which humans and mountains have sustained each other over the centuries; and the conservation legacy of the Smiley family, beginning in 1869 and spanning five generations at Mohonk.

Chapter 1 opens with the first people to arrive after the glaciers receded, the Paleo-Indians. For centuries, they and later Native American groups hunted in the Shawangunks and crossed its ridges on long-established footpaths. The 300-foot-high cliff escarpments facing east toward the Wallkill Valley formed a barrier to human settlement on the mountain until the late 1700s, more than a century after European immigrants began settling the surrounding valleys. Families initially moved into the Shawangunks from the Rondout Valley, up the gentler slopes to the west. During the 19th century, mountain communities grew, with residents eking out a subsistence living, using every resource available from the rocky terrain. Chapter 1 ends with mountain resident John F. Stokes opening a small inn with tavern at Mohonk Lake in 1859.

Subsequent chapters cover 30-year periods. Chapter 2 begins with the establishment of Mohonk Mountain House in 1869 by Quaker twins Albert and Alfred Smiley. Ten years later, Alfred moved to Minnewaska Lake to the south, where he constructed two mountain houses. Albert, joined by younger, half-brother Daniel Smiley, continued to build Mohonk into

a mountain haven for guests. The Smileys also contributed to the cultural and educational climate of New Paltz and other communities, including Redlands, California, where the family lived during the winter when Mohonk was closed. Between 1883 and his death in 1912, Albert sponsored annual conferences at Mohonk on behalf of Native Americans and for International Arbitration. Continued for a few years after Albert's death, the conferences were well ahead of their time. The Indian conferences, in particular, fostered new concerns for native people and the conditions under which they were struggling to survive.

Chapters 3 and 4 document everyday life on the mountain from 1900 through the 1950s. It is fortunate that thousands of photographs were taken of activities and work during this period by Daniel's son, A.K. Smiley, and by A.K.'s son, Dan Smiley. For many years after, Dan and his sister-in-law, Ruth Happel Smiley, continued to photograph Mohonk's splendid scenery and varied life. It is equally fortunate for future generations that these and many other historical photographs are carefully preserved in the archives at Mohonk Mountain House and at the Daniel Smiley Research Center of the Mohonk Preserve, as well as in other public and private collections.

Chapters 5 and 6 focus on continued endeavors to protect the Shawangunks. The conservation legacy of the Smiley family, founded in the 19th century, began a new era with the creation in 1963 of the Mohonk Trust, a land conservancy created from Mountain House property. In 1978, the Mohonk Trust became the Mohonk Preserve; today it is the largest nature preserve supported by members and visitors in New York State. One photograph near the end of chapter 6 symbolizes the conservation efforts of this period—a peregrine falcon chick successfully reared at its traditional nesting cliffs for the first time in 40 years. The reappearance of the peregrines and other species signals a healthier balance of the Shawangunk ecosystem and a more secure future for this land of sky lakes and sheer cliffs.

Note: Every effort was made to check the information presented with the generous assistance of those listed in the acknowledgments. Regardless, any errors are entirely my own. I welcome comments and corrections, which can be sent to rjhudson@hvc.rr.com. Finally, this book, my first, is dedicated to my late parents, Vincent E. and Ann K. Josephson, who named me Roberta after the Broadway musical and who made everything possible.

One
BEGINNINGS: UP TO 1869

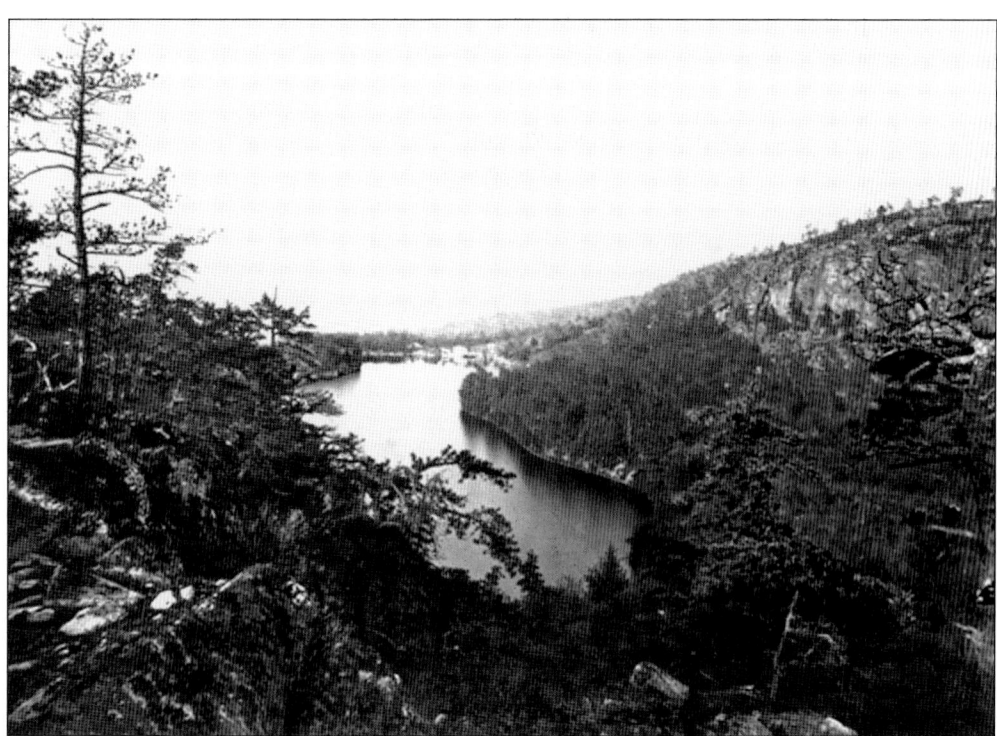

"Looking North c. 1865" is one of the earliest known photographs taken of Mohonk Lake. For centuries, Native Americans had hunted in the vicinity. Later, descendants of European settlers harvested Shawangunk forests and quarried its stone. During the 19th century, the crack of the axe and chisel reverberated across the stillness of Mohonk Lake. (Courtesy of MP-DSRC.)

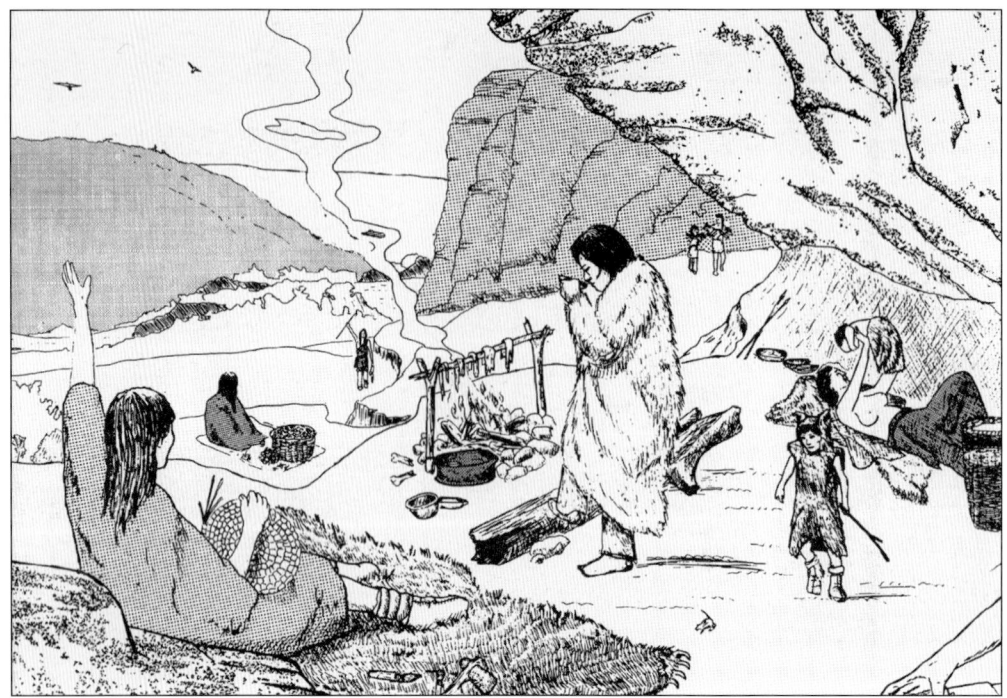

An early Native American family camps at a rock-shelter. Beginning about 10,000 years ago, after the last ice sheets melted, people called Paleo-Indians arrived in the Hudson Valley. From these nomadic hunters and gatherers to the Lenape villagers who met the first Europeans, native people took shelter under rock overhangs and in caves when hunting in the Shawangunks and other mountainous terrain. (Sketch by John T. Kraft.)

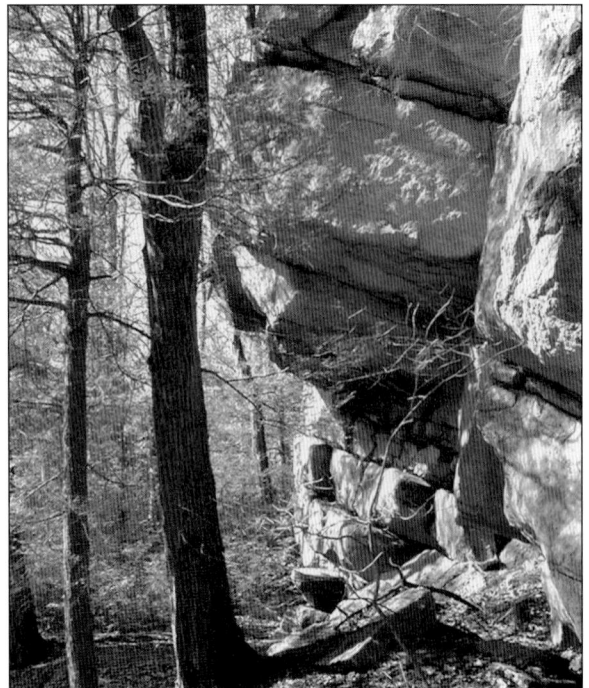

Rock-shelters provided temporary protection from the elements when native people hunted away from their villages. Found throughout North America, these rock overhangs are formed when water and ice erode rock from the base of a cliff, leaving a roof above. According to historian Alf Evers, Dutch settlers called these rock-shelters "*jagd houses*," or "hunting houses." The rock-shelter shown here is on lands protected by the Mohonk Preserve. (Photograph by Robi Josephson.)

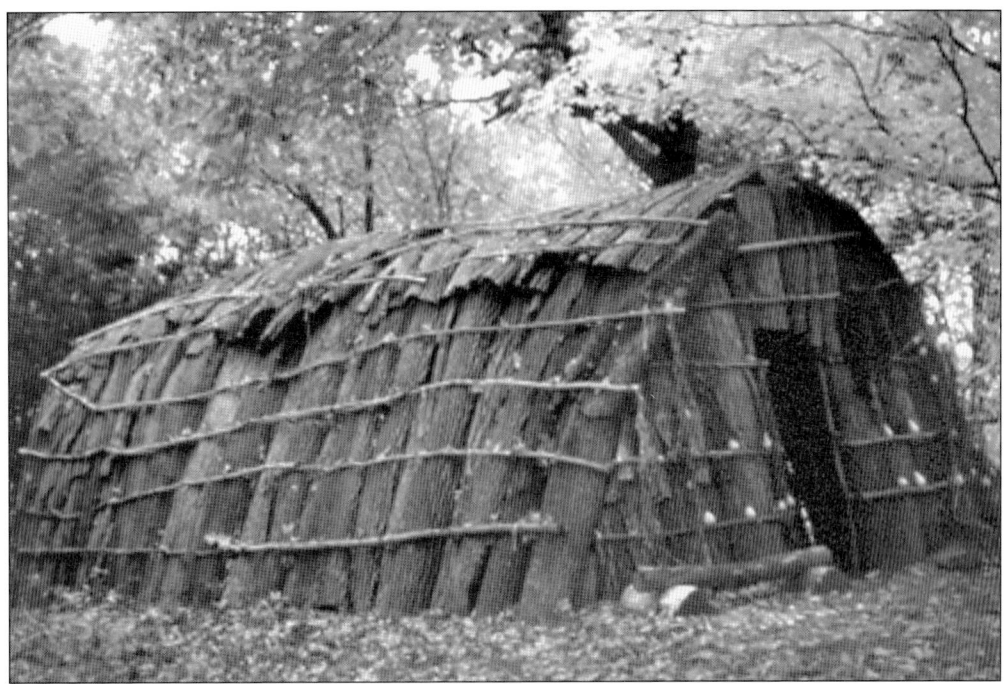

Northeast woodland people, including the Lenape, once lived in longhouses made with saplings and covered with bark shingles or grass mats. Several families typically lived in one longhouse. The one pictured here, built by staff and volunteers of the Mohonk Preserve, is used for outdoor education classes to demonstrate traditional native culture. (Courtesy of Mohonk Preserve.)

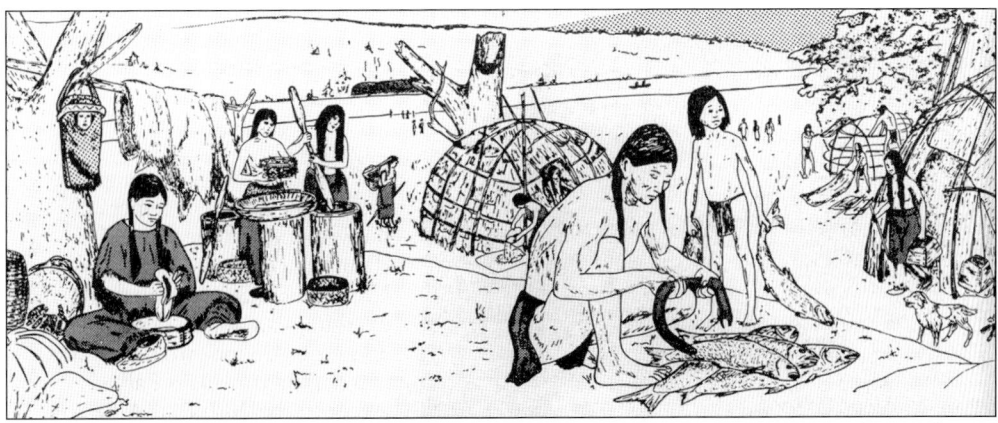

According to archaeologists, the development of horticulture and pottery making allowed nomadic people to settle into semipermanent villages. In this area, groups lived in the valleys adjacent to the Shawangunks. Over time, the Indians of the mid-Hudson Valley south to Delaware Bay became known as the Lenape. Europeans named them the Delaware. The closest Lenape village to Mohonk was on the Wallkill River near New Paltz. (Sketch by John T. Kraft.)

European immigrants to the Hudson Valley included the Dutch, the English, and the French Huguenots. The French Huguenots established the town of New Paltz in 1677. They paid tools, weapons, and clothing to the Lenape for nearly 40,000 acres from the Hudson River to Paltz Point, the former name for Sky Top. The Huguenots built stone houses and a fort in New Paltz, shown here, which are open seasonally as part of a historical site. (Photograph by Robi Josephson.)

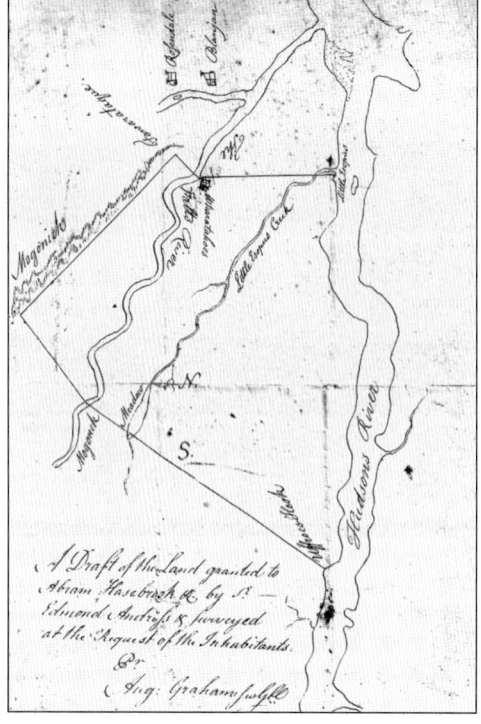

"Mogonick" appears on August Graham's 1709 map above the Shawangunks, marking the western boundary of lands deeded to the French Huguenots. Mohonk and Shawangunk are European transliterations from the Lenape language. Lenape scholars have suggested several meanings for Mohonk: raccoon-skin coat, eat solid food, place of a great tree, or on the great sky top. Shawangunk may mean the place of going south, south water or south mountain, large white rock, or at the hillside. (Courtesy of HHHC.)

A detail of an 1860 map shows the "Traaps" (lower right) from a Dutch word meaning steps. Boxes designate the homesteads of families named Van Leuven, Burger, and Davis who settled this area near Mohonk beginning in the late 1700s. The community, also called the Trapps, peaked c. 1880 with about 50 homesteads, a school, a tavern, a mill, and a chapel. Today, much of this land is managed by the Mohonk Preserve and Minnewaska State Park Preserve. (Courtesy of HHHC.)

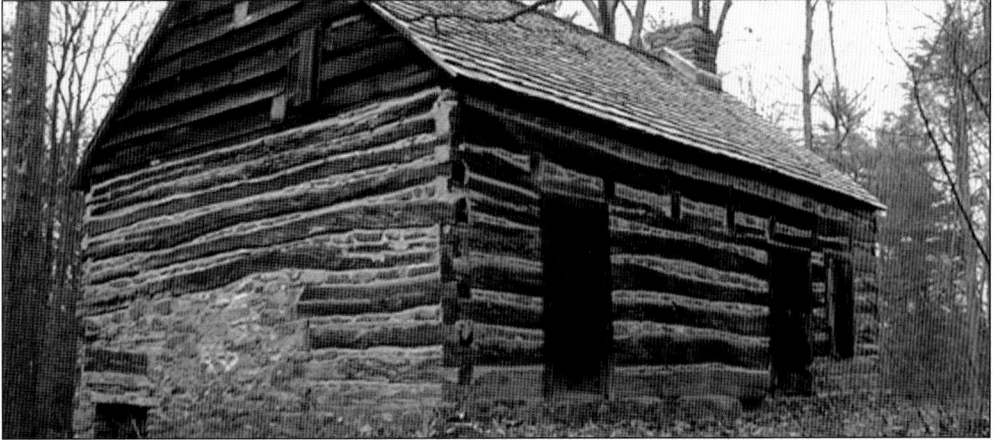

Adam Yaple, son of German immigrants, built this log cabin near Mohonk c. 1771. One of the earliest settlers in the Northern Shawangunks, Yaple farmed the land with his Dutch wife, Arrientje Hendrickson, and their 11 children. The cabin has a fireplace, loft, root cellar, and decorative stonework between hand-hewn logs. During the 1800s, it was part of a mountain community called Yeapletown. Mohonk Mountain House owns and maintains the cabin today. (Photograph by Ted Reiss.)

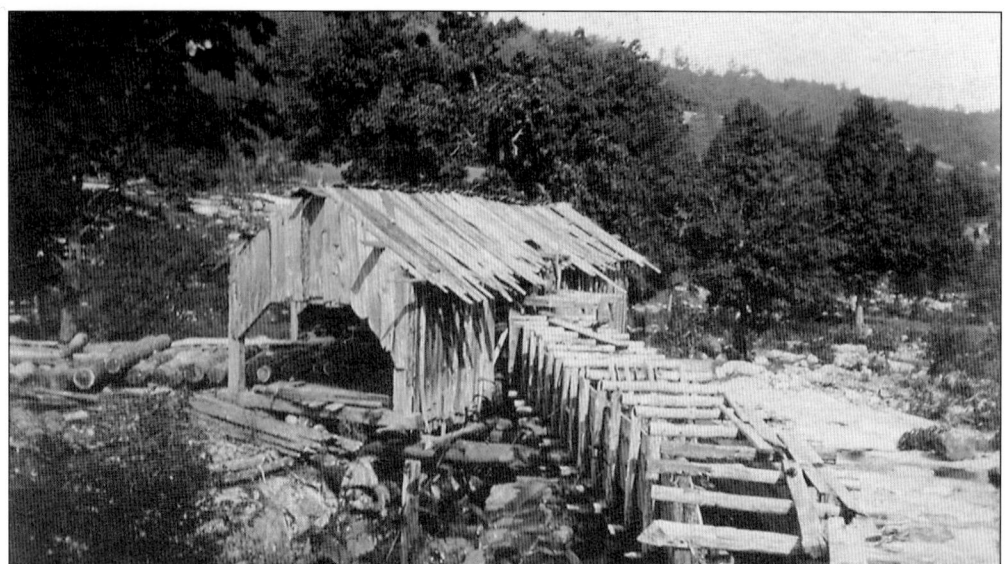

Johannes Enderly established this sawmill in the early 1800s in the Trapps. A stream called the Coxing Kill powered the mill and provided water for residents. "Kill" means stream in Dutch. Johannes's son, William, and grandson, Hiram, continued to operate the sawmill until *c.* 1920. The mill no longer stands, but its saw blade may be viewed at the Mohonk Preserve Visitor Center. The Mohonk Preserve owns and maintains the site today. (Courtesy of MP-DSRC.)

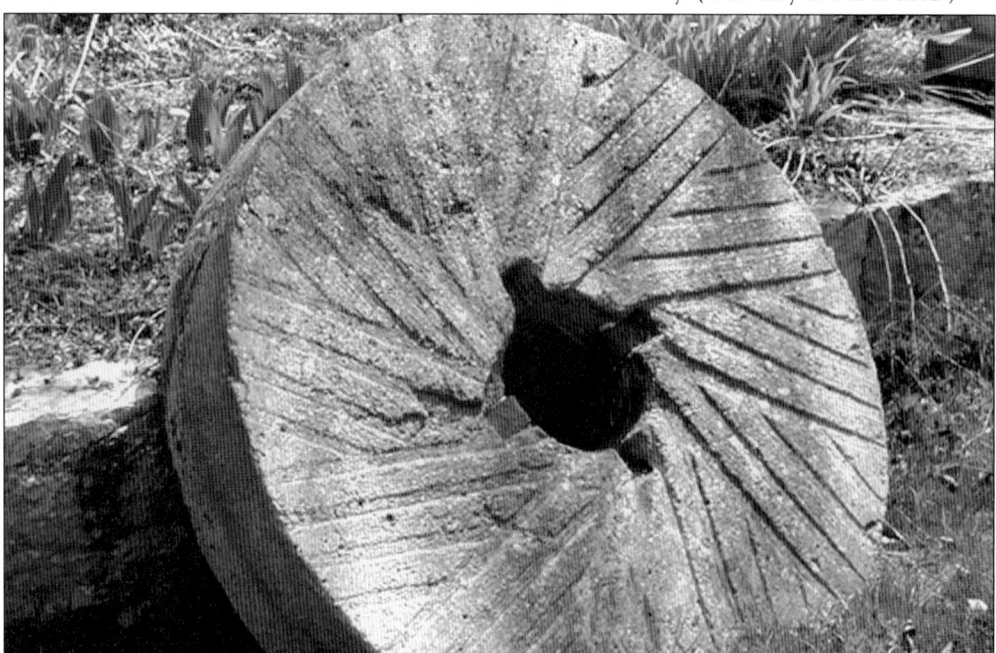

Ed Pastusak of nearby High Falls owns this Pennsylvania millstone dressed with a "land-and-furrow" pattern. The Shawangunks provided 90 percent of America's millstones at the industry's height in 1883. At that time, about 350 tons of millstones were cut yearly at a number of quarries and shipped out via the Delaware and Hudson Canal and the Wallkill Valley Railroad. The Delaware & Hudson Canal Museum in High Falls is open seasonally and features exhibits about canal history. (Photograph by Robi Josephson.)

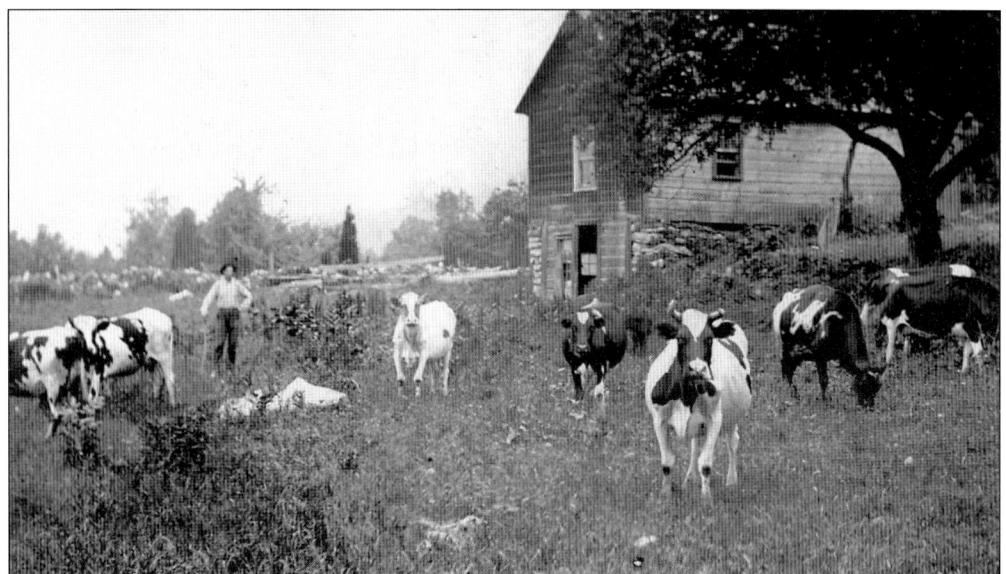

Ed Enderly tends his herd in a typical mountain farm scene of the 1800s and early 1900s. After clearing rocky, forested land, families like the Enderlys supported themselves by subsistence farming and with cash-generating activities: making butter, charcoal, and barrel hoops; harvesting wood, nuts, and berries; quarrying millstones; and distilling wintergreen oil. After 1869, adults also worked seasonally for the Mohonk and Minnewaska Mountain Houses. (Courtesy of Enderly descendant Joan Wustrau.)

John F. Stokes opened a 10-room inn with tavern at Mohonk Lake on July 4, 1859. According to eyewitness accounts in local newspapers, festivities included a great bonfire, square dancing, and music by the Kerhonkson Brass Band. The tavern became popular with young people for outdoor dances, shooting matches, and skating parties. Stokes also harvested hemlock bark for tanning and other wood products on the property for income. (Courtesy of MMHA.)

John F. Stokes strolls along Lake Shore Road. His endeavor at "Lake Mohunk" lasted 10 years. In 1864, Stokes lost $1,000 in marketable hemlock tanbark after a forest fire burned over 300 acres. In 1867, his wife of 42 years, Jane, passed away. In 1869, Stokes accepted Albert Smiley's offer to buy the inn with tavern and about 300 acres. Stokes returned to his farm in nearby Yeapletown and died there in 1873 at age 71. (Courtesy of MMHA.)

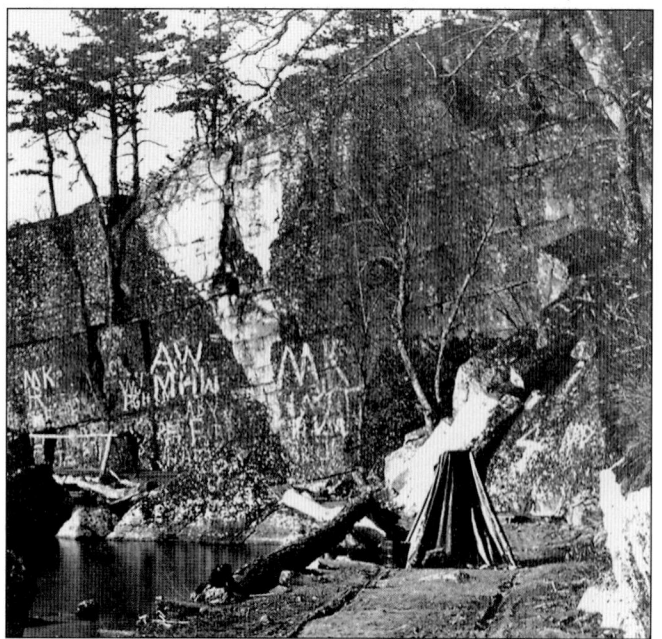

This 1860s photograph of Lake Shore Road along Mohonk Lake shows graffiti carved into the lichen on the cliff at the rear. Lichen is a plant composed of algae and fungi that grows on rocks and trees. Lichen once covered the cliffs at Mohonk and elsewhere in the Shawangunks but today occurs to a much lesser degree due to changes in air quality. (Courtesy of MMHA.)

Two

A Mountain Haven Is Born: 1870–1899

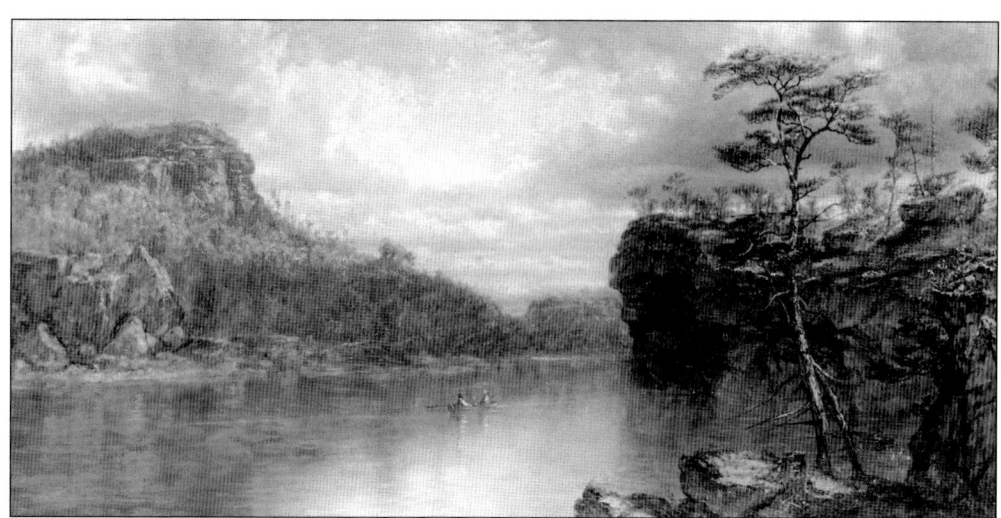

Two guests are dwarfed below Sky Top (left) and Pine Bluff (right) in Daniel Huntington's painting *Lake Mohonk, 1872*. Huntington was a Hudson River school artist and portrait painter. He sketched at Mohonk Lake beginning in the 1830s and later became a good friend of the Smileys. Huntington's portraits of Albert K. and Eliza Smiley hang in the main parlor at Mohonk Mountain House. (Courtesy of MMHA.)

A boater surveys the first addition to John Stokes's original tavern. Its interior was renovated and its rear section was replaced with a four-story building for the grand opening of Mohonk Mountain House on June 1, 1870. Years later, Albert Smiley recalled that during the first season "the house filled up with our friends" from New York and Philadelphia. (Courtesy of MMHA.)

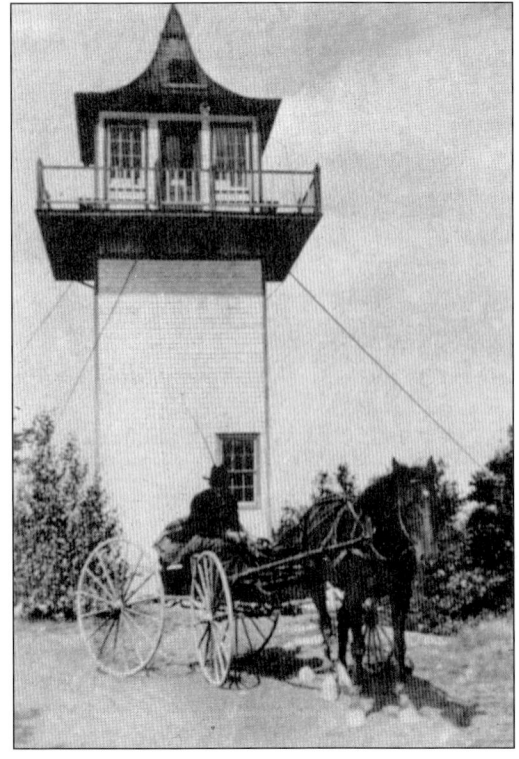

Three wooden structures stood on Sky Top before the current stone tower was constructed in the early 1920s. The first, built in 1870, was destroyed by a severe wind storm. The second tower stood from 1872 to 1877, and the third, shown here, lasted from 1878 to 1909; both were destroyed by fire. (Courtesy of MMHA.)

Born in Maine to a Quaker family, twins Alfred H. Smiley (1828–1903) and Albert K. Smiley (1828–1912) were educators who became proprietors of Mohonk Mountain House in November 1869. Most people could not tell the twins apart. Mohonk scholar Larry Burgess notes, "They were both fond of teasing their friends and especially members of their own families." One small detail revealed their secret: Alfred, left, wore a square watch fob and Albert, a round one. (Courtesy of MMHA.)

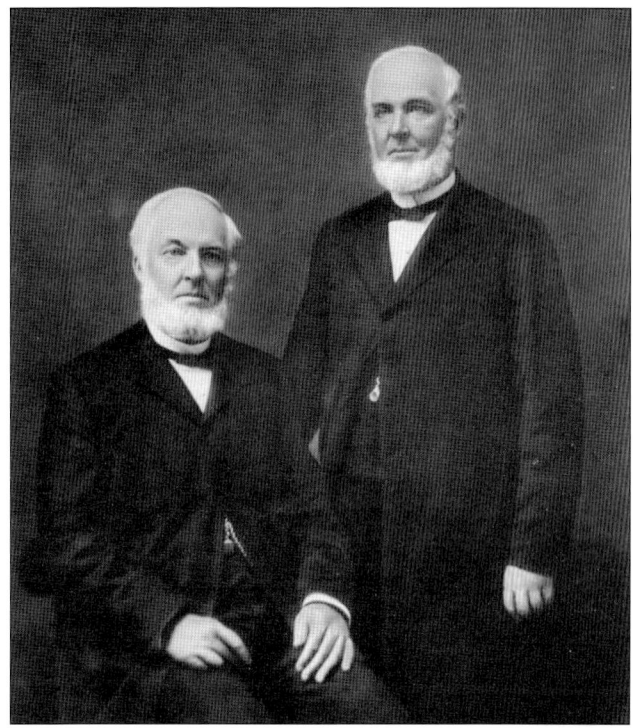

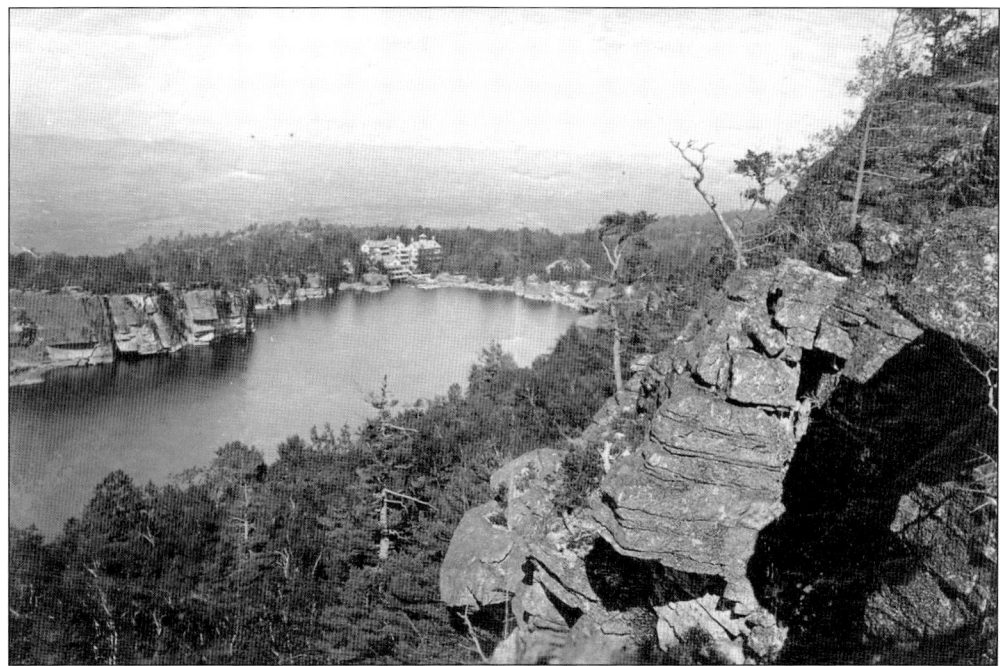

This 1871 view from Sky Top shows an expanding Mountain House with three additions behind it. The one at right has a six-sided observatory on top. Observatories and towers were popular during the 19th century as a way to experience a romanticized view of nature. Viewing platforms enabled guests to see the natural world around them with ease. (Courtesy of MMHA.)

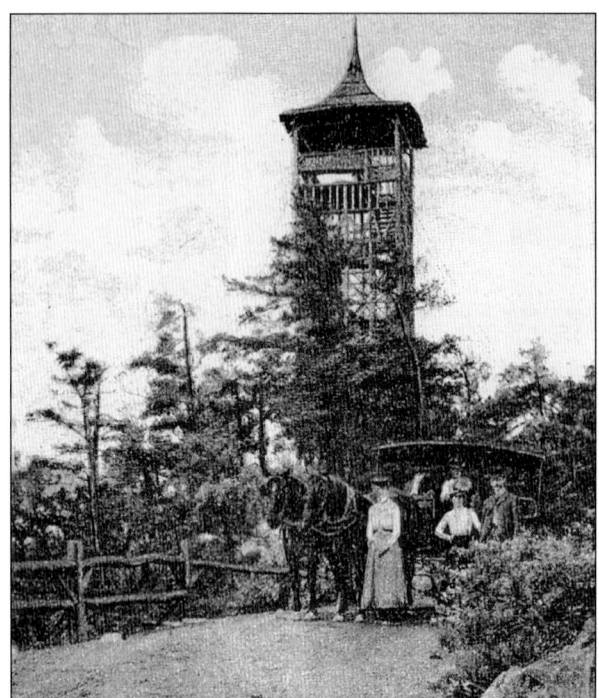

A group poses at the wooden tower on Eagle Cliff. The tower was built in 1880 and stood until 1973. Its observation platform afforded panoramic views of the Shawangunks, the Catskills, and surrounding valleys. Eagle Cliff is a short walk from the Mountain House along Eagle Cliff carriage road, built in 1872. The postcard was mailed in 1906 to Lena Abrams, Mountain Rest, New York, with the greeting "Everybody Happy." (Courtesy of HHHC.)

A parishioner leaves Clove Chapel in Yeapletown, a mountain community near Mohonk. The chapel was constructed in 1876 with funds donated in part by Mountain House guests; it still stands. Eliza Smiley, Albert's wife, arranged for ministers staying at the Mountain House to lead occasional services at the chapel, taken there and back by "the old white horse." The photograph appeared in a 25th-anniversary booklet published by the Mountain House. (Courtesy of MMHA.)

Dr. Theodore L. Cuyler led services at Mohonk from 1875 to 1905. He was an eminent Presbyterian pastor of the Lafayette Church in Brooklyn. In 1872, he outraged the elders by allowing a woman—Sarah F. Smiley—to preach from the church pulpit. Sarah Smiley, the younger sister of Albert and Alfred Smiley, was a controversial preacher for her time. (Courtesy of MMHA.)

Sarah F. Smiley (1830–1917) was a devout Quaker who traveled to the South after the Civil War on relief missions for fellow Quakers in need. She preached extensively in the United States and Great Britain at a time when women had few rights. She also founded a home Bible study program for women. Guided by her faith, she wrote in her journal that she "felt great liberty to speak the truth in love." (Courtesy of MMHA.)

The Wallkill Valley Railroad was extended to New Paltz six months after the Mountain House opened. It shortened the trip from New York City to 3 hours, 15 minutes. Many of Mohonk's early guests came from the New York City and Philadelphia metropolitan areas and depended on railroad transportation. In town, the local newspaper proclaimed the railroad's arrival was "A Great Day for Old Paltz." (Courtesy of HHHC.)

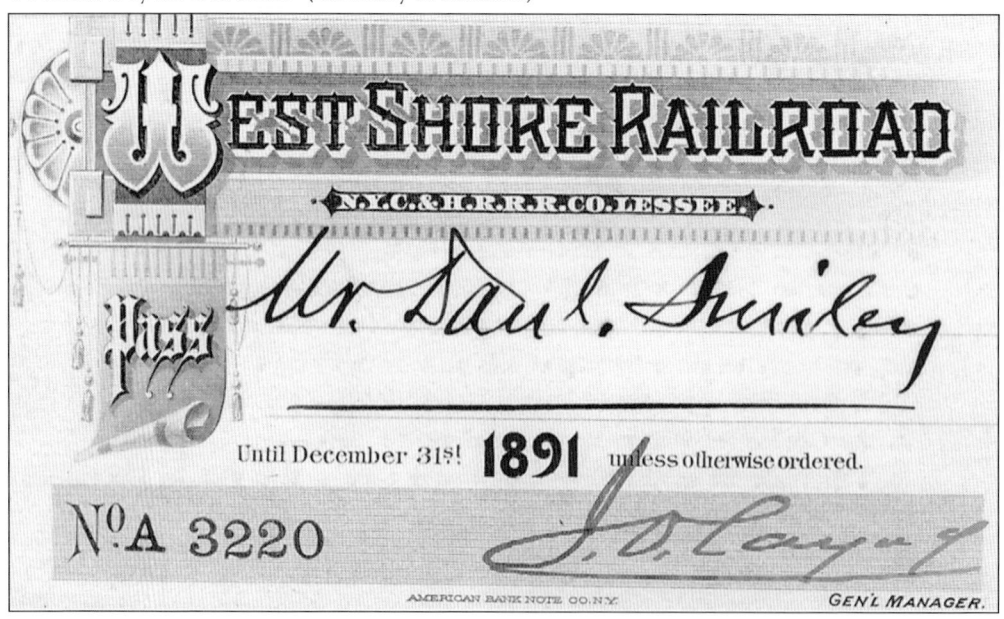

Daniel Smiley, Albert and Alfred's younger half-brother, received a free pass in 1891 for the West Shore Railroad, completed up the Hudson River in 1883 through the scenic Hudson Highlands. The Smileys could then recommend the railroad to guests as an alternative route to and from New York City. From the West Shore Depot in the town of Highland, a Mohonk stage brought guests through New Paltz and up the mountain. (Courtesy of Vivian Yess Wadlin.)

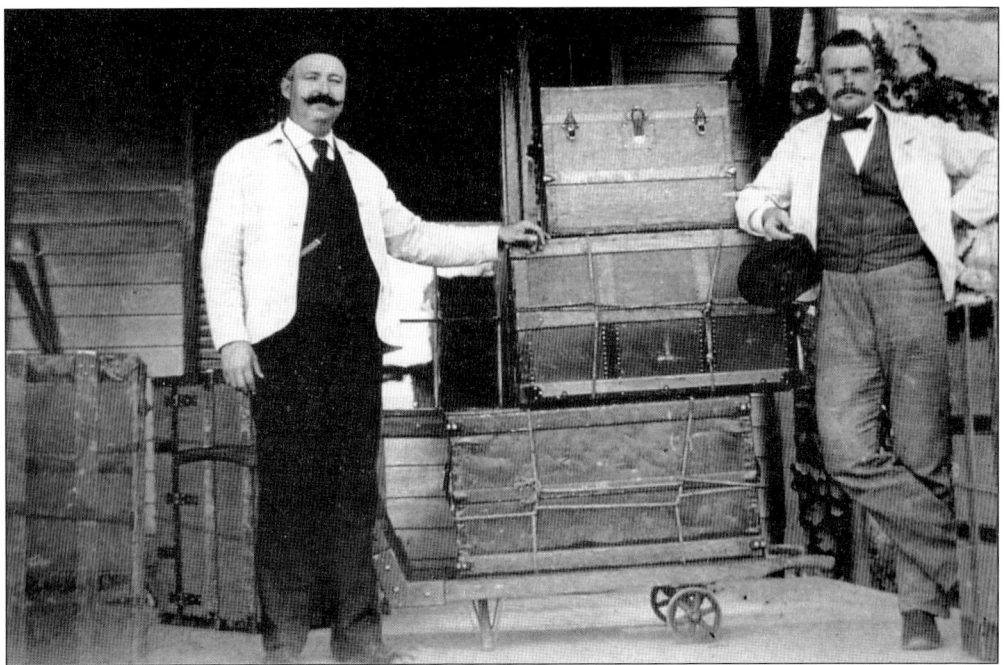

Porters handled heavy loads during the early years at Mohonk Mountain House. Guests often stayed for extended periods, bringing several steamer trunks of clothes and personal items. Women's fashions of the day included long skirts, bustles, and many accessories, which also required large trunks for transport. (Courtesy of MMHA.)

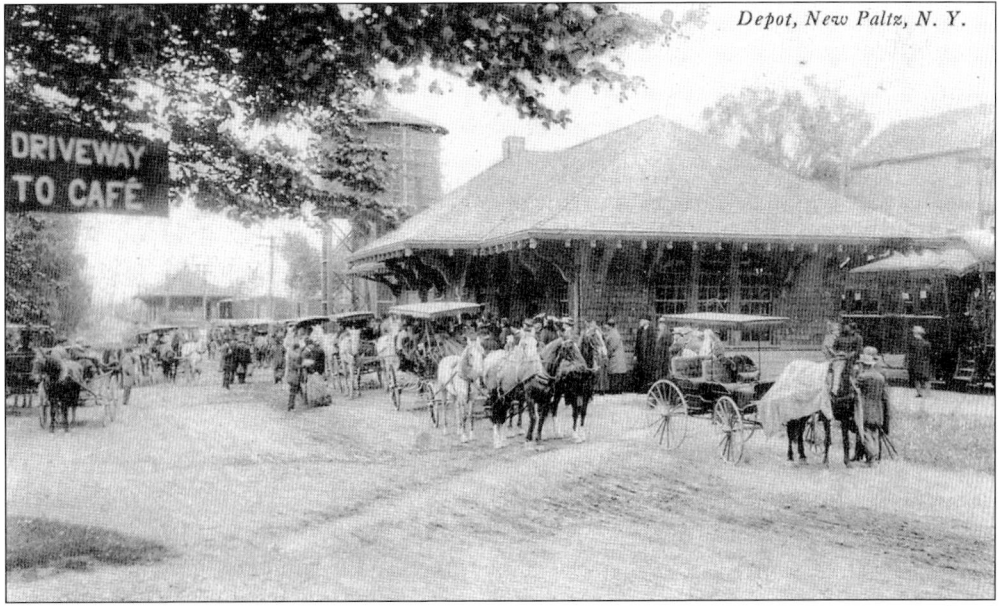

Before the advent of automobiles, Mountain House guests were picked up by surreys at local railroad depots, including the New Paltz Depot, shown here. Luggage was transported separately by wagon. According to *Mr. Dan's Landmark Walk*, each Mohonk stage driver was responsible for a particular vehicle. Each driver was issued lap robes for the guests, a kerosene lantern, a sponge for washing the vehicle, and a jack for greasing axles. (Courtesy of MMHA.)

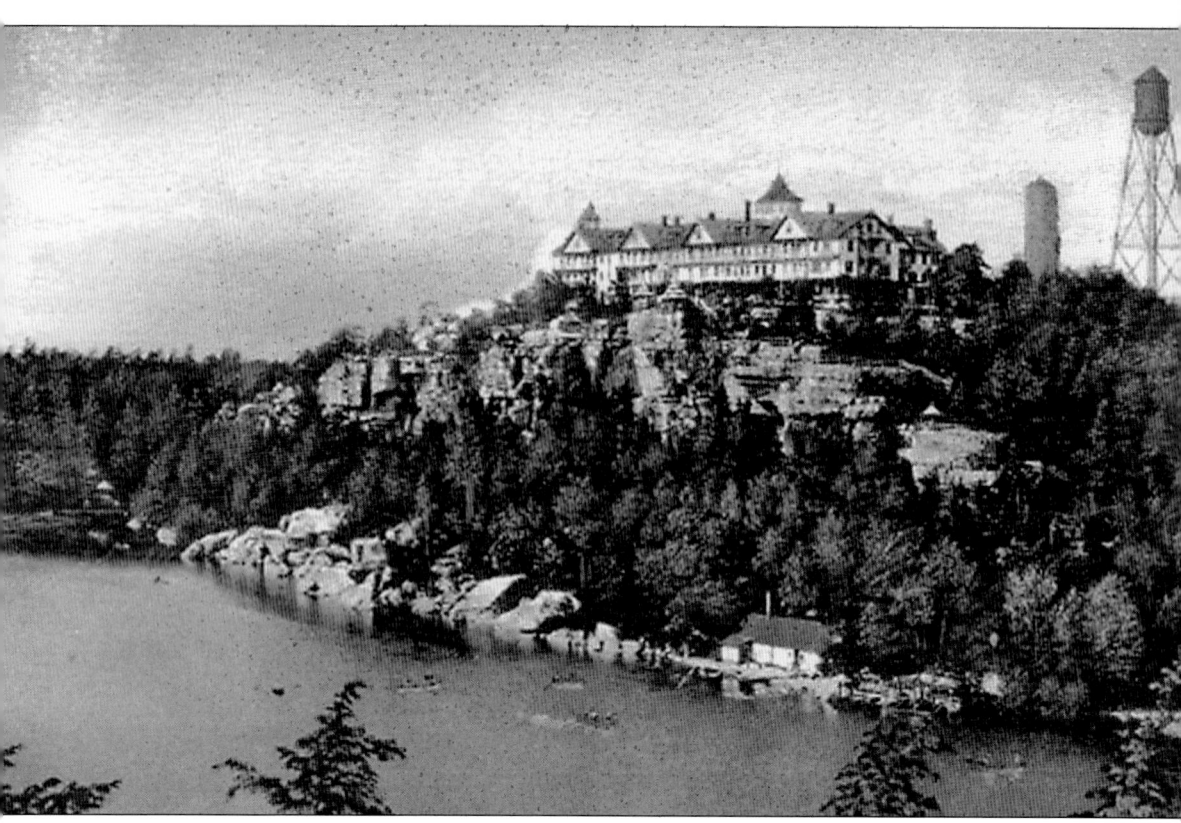

In 1875, Alfred Smiley discovered another lake called Coxen Pond to the south of Mohonk. Trapps resident George Davis sold the lake and surrounding property to Alfred, who renamed it Minnewaska Lake. Although still manager of Mohonk, Alfred constructed a hotel there, Cliff House, shown here with a water tower and a bathhouse. Alfred moved to Minnewaska full-time in 1878, opened Cliff House the following year, and constructed a second hotel, Wildmere, in 1887. He eventually expanded the property to 10,000 acres. In 1955, Alfred's grandson sold it to Kenneth and Lucille Phillips. In 1972, they sold 7,000 acres to the Nature Conservancy, which transferred the land to the Palisades Interstate Park Commission. With this land, the commission created Minnewaska State Park Preserve. Between 1978 and 1986, both hotels burned down, and environmental groups and concerned citizens defeated plans for an expansive hotel complex. In 1987, the remaining acreage was added to the Minnewaska State Park Preserve. (Courtesy of MMHA.)

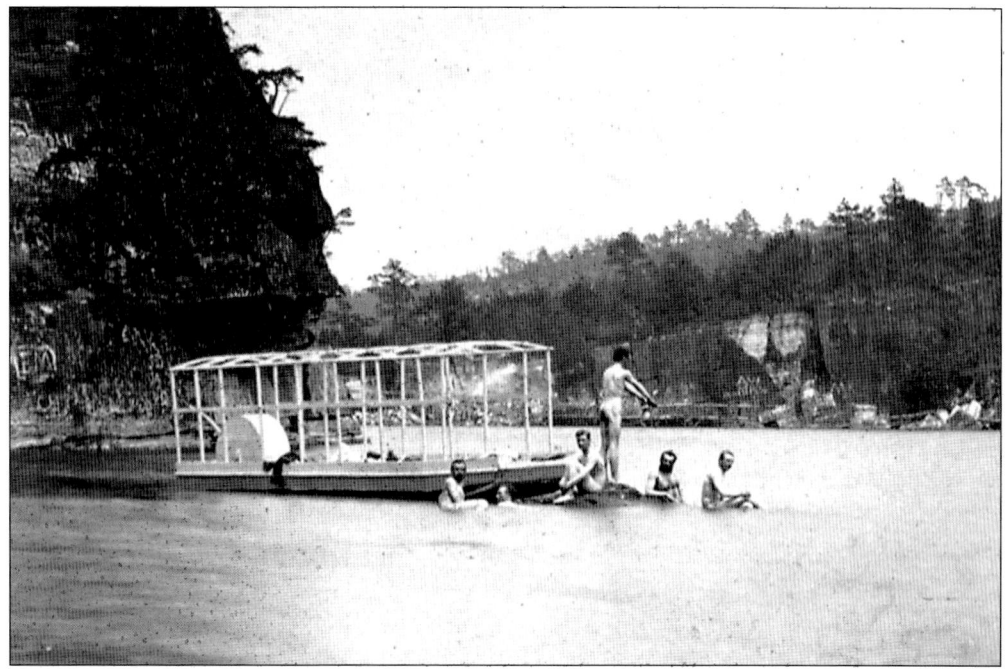

A group of men swim at Mohonk Lake c. 1870. Convention then did not allow women to swim. The paddle wheeler was the only way at that time for the men to reach a private spot away from the Mountain House. The paddle wheeler later sank and is believed to still lie at the bottom of the lake. This photograph was taken at the site of the present-day beach area. (Courtesy of MMHA.)

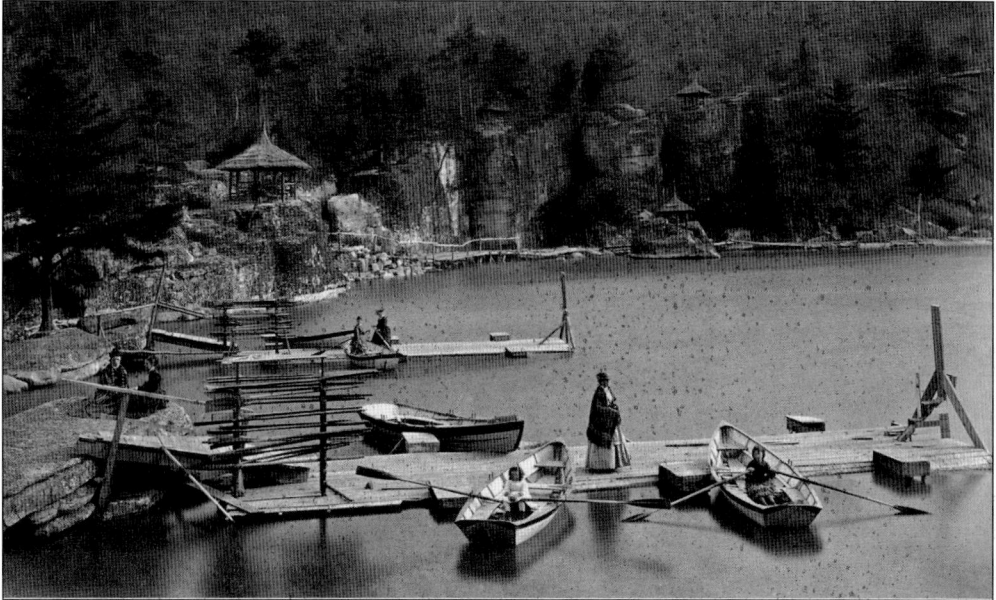

A woman looks out over Mohonk Lake, while two children sit in rowboats at the boat wharf c. 1875. Behind them, summerhouses dot the cliff rising toward Sky Top. Summerhouses are traditionally more rustic versions of gazebos. Sky Top is bare of trees, the result of an 1864 fire that destroyed over 300 acres when John F. Stokes owned the property. (Courtesy of MMHA.)

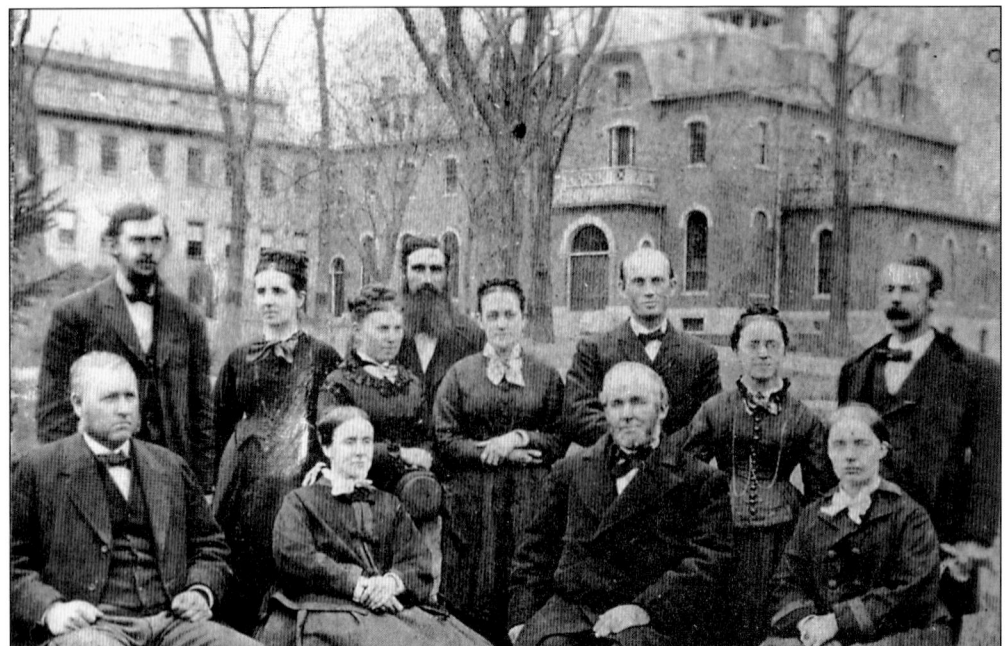

Eliza and Albert Smiley (front center) pose with faculty of the Friends Boarding School in Rhode Island. After purchasing Mohonk in 1869, Albert continued as principal of the Quaker school until 1879, when he moved to Mohonk. Throughout his life, Albert was committed to higher education. He served as a trustee and president of the New York State Normal School at New Paltz, and as a trustee of Vassar College, Brown University, and Pomona College. (Courtesy of MMHA.)

Established in 1833, the New Paltz Academy stood on Huguenot Street in New Paltz until a fire destroyed it in 1883. Academy trustee Albert Smiley hosted discussions at Mohonk for educators wishing to see the Academy become a state normal school for the training of public school teachers. Their wish was realized in 1885, and Albert was elected the first board president of the New York State Normal School at New Paltz, built on the same site. (Courtesy of HHHC.)

After Alfred Smiley left Mohonk to run Minnewaska, Albert Smiley recruited younger half-brother, Daniel Smiley, pictured here, to come to Mohonk in 1881 and help build and manage the business. Daniel was proprietor from 1892 until his death in 1930. All of the current members of the Smiley family operating the Mountain House are Daniel's descendants. Daniel served as a trustee and president of the New York State Normal School at New Paltz and as a trustee of Haverford College and the University of Redlands. (Courtesy of MMHA.)

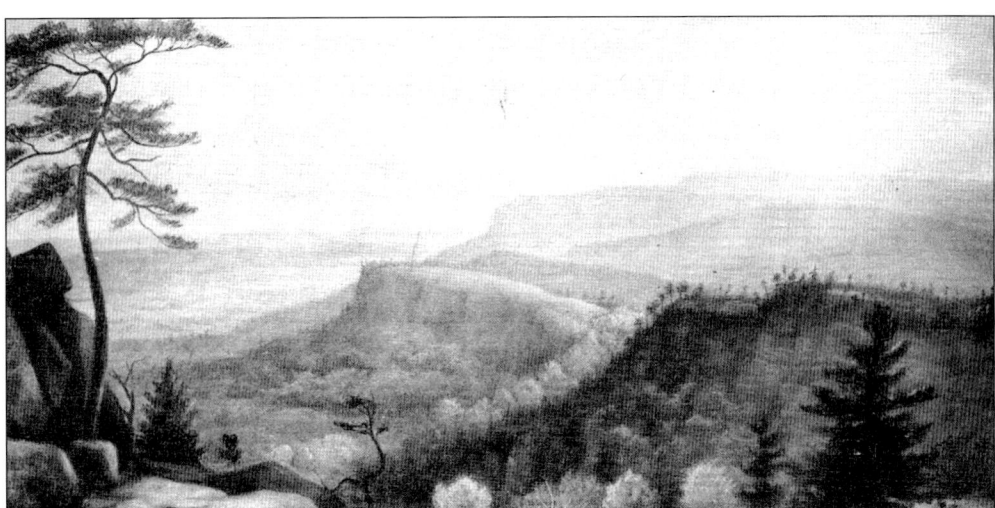

J.R. Lambdin's 1881 *Shawangunk Mountains, From Sky Top, Lake Mohonk* reflects the Smiley family vision of land stewardship for the Shawangunk Mountains. The lands depicted are protected today by Mohonk Mountain House, the Mohonk Preserve, and Minnewaska State Park Preserve. Lambdin's Glen, a narrow ravine near the Mountain House, was named in honor of this American painter best known for his portrait of Pres. John Tyler. (Courtesy of MMHA.)

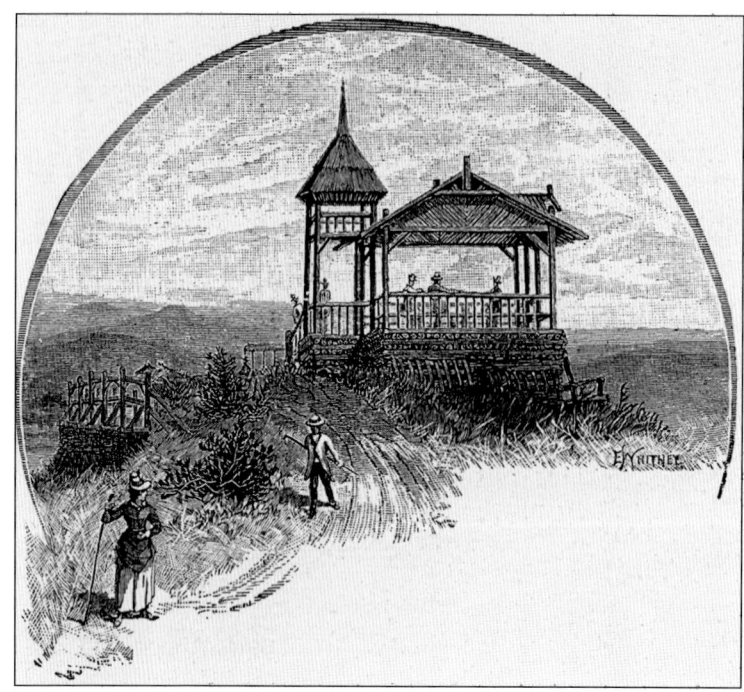

Commanding vistas await guests at the Guyot's Hill summerhouse near Mountain Rest. Albert Smiley purchased the knoll in 1880 and built the carriage road to its top in 1882. He named the hill, carriage road, and summerhouse in honor of his guest and friend Arnold H. Guyot, a Princeton professor. Today, the summerhouse is gone and the forest has returned. (Engraving by E.J. Whitney/Courtesy of MMHA.)

A gentleman tips his hat to a lady in the formal gardens at Mohonk Mountain House. Albert Smiley planted Mohonk's earliest garden—a bed of geraniums—near the lake among the pines and mountain laurel that surrounded the original inn. Over time he expanded the gardens in their present location along Garden Road. (Courtesy of MMHA.)

The Smiley family gathers around Daniel Smiley's first child, Albert, for this c. 1886 portrait. The adults, from left to right, are Mary Cornell, a relative; Daniel's wife, Effie; Albert's wife, Eliza; Albert; and Daniel. Named for his uncle, young Albert was called Bertie as a baby and was referred to as A.K. as an adult. He was the second of four Albert Keith Smileys at Mohonk. (Courtesy of MMHA.)

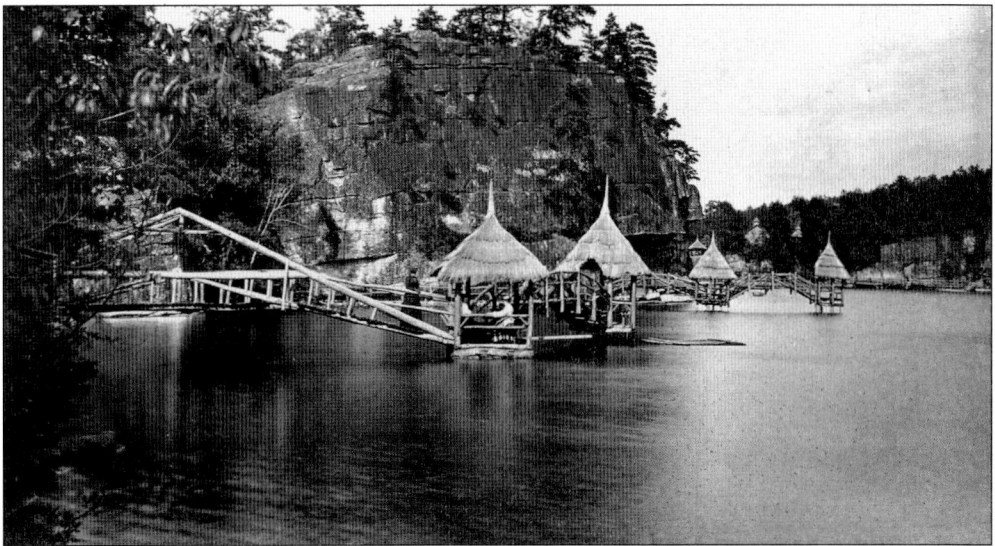

Summerhouses at the Swiss Village sit on stilts during the early 1880s. Bridges connect them to a walkway on the shore. These structures were popularized earlier in the 19th century by Hudson Valley landscape architect Andrew Jackson Downing. Gazebos traditionally are more enclosed and made of finished lumber. Roof thatch was later replaced by hemlock slabs and more recently by cedar shingles for durability. (Courtesy of MMHA.)

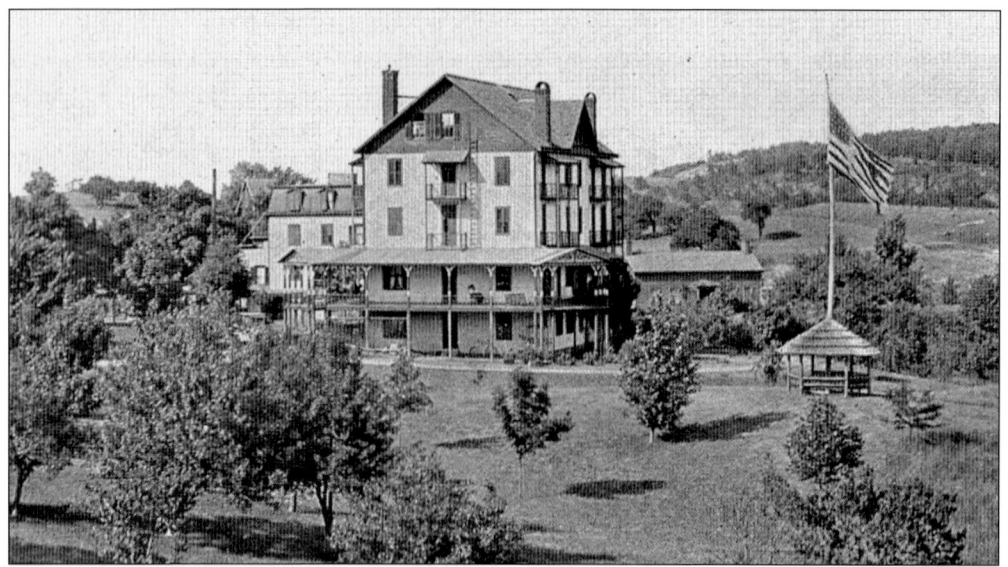

The Mountain Rest Boarding House opened in 1885 in the area of the current gatehouse. It provided spectacular views of the Catskill Mountains and surrounding valleys. The boardinghouse provided full hotel services and activities but less expensive accommodations for 80 guests. J. Irving Goddard was manager of the boardinghouse until it burned down in 1907. (Courtesy of MMHA.)

A young boy emerges from a crevice in a photograph appearing in an 1875 Mohonk Mountain House guidebook. He is in a section of talus, the boulder rubble that has eroded and fallen from the cliff face. Trails are designed to lead guests safely through crevices and other dramatic rock formations on lands of the Mountain House and the Mohonk Preserve. (Courtesy of MMHA.)

Albert Smiley poses with guests c. 1890 at a trailhead on the grounds of the Mountain House. He frequently led guests on nature walks, a tradition continued down the years by the Smiley family. With extensive grounds to explore and varied activities to participate in, guests over the years have had many opportunities "to refresh body, mind, and spirit" during a stay at Mohonk. (Courtesy of MMHA.)

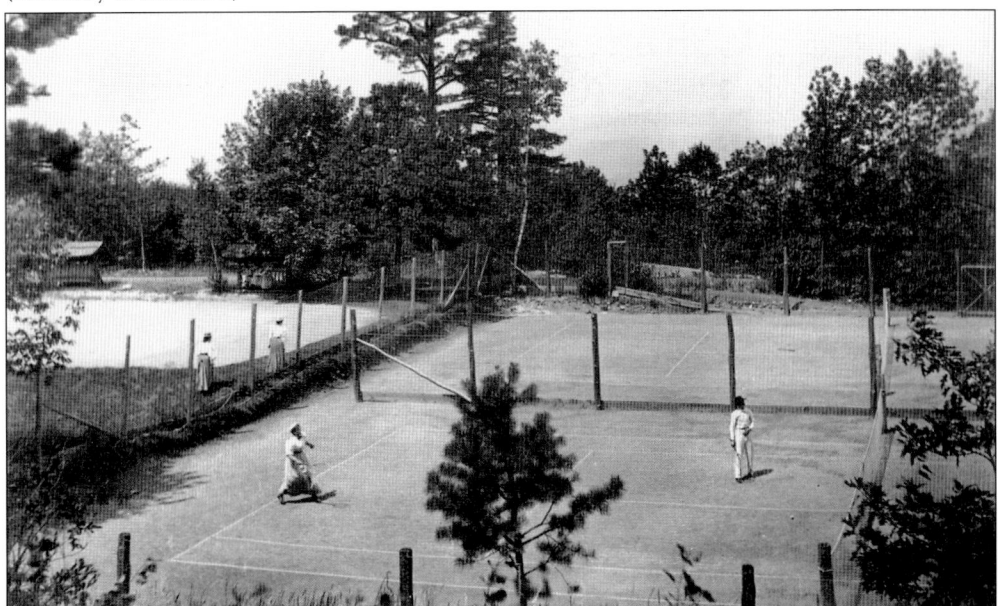

Tennis has been played at Mohonk since 1883, when the first courts were built close to the Mountain House. In 1910, additional clay courts were built near the bathing beach. Annual tournaments began in 1921. (Courtesy of MMHA.)

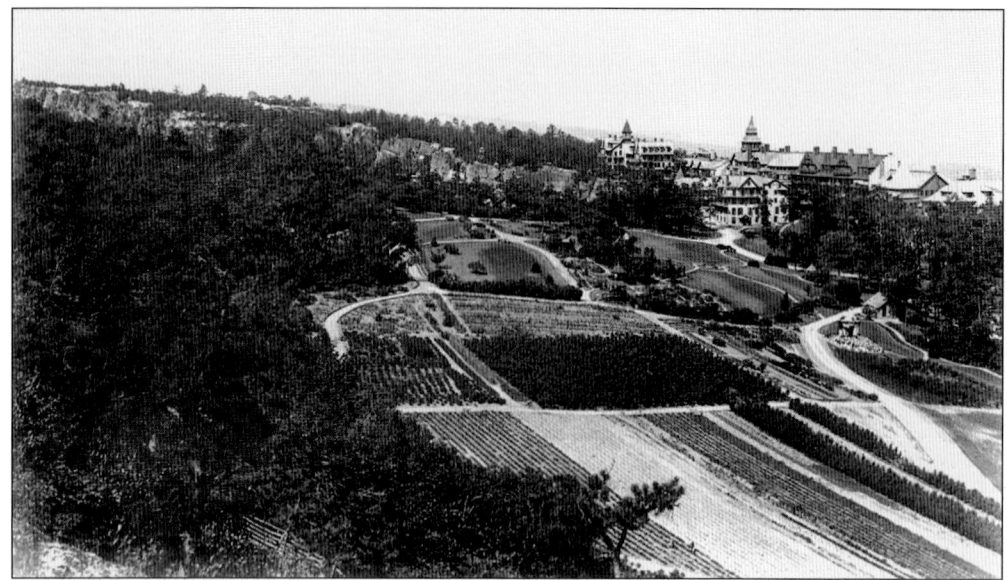

Beds of berry bushes sweep away from the Mountain House in this c. 1890s photograph. A variety of berries, including raspberries, gooseberries, and blackberries, were grown to be picked and enjoyed by guests. The last bed of berry bushes was pulled up in the 1970s because they were too labor intensive to maintain. Today, this area is part of the formal gardens. (Courtesy of MMHA.)

A young woman gazes across Mohonk Lake from Lake Shore Drive near the Mountain House in this 1895 photograph. (Courtesy of MMHA.)

Balancing an immense bow atop her hat, a flower girl stoops to gather blooms from Mohonk's gardens during the 1890s. (Courtesy of MMHA.)

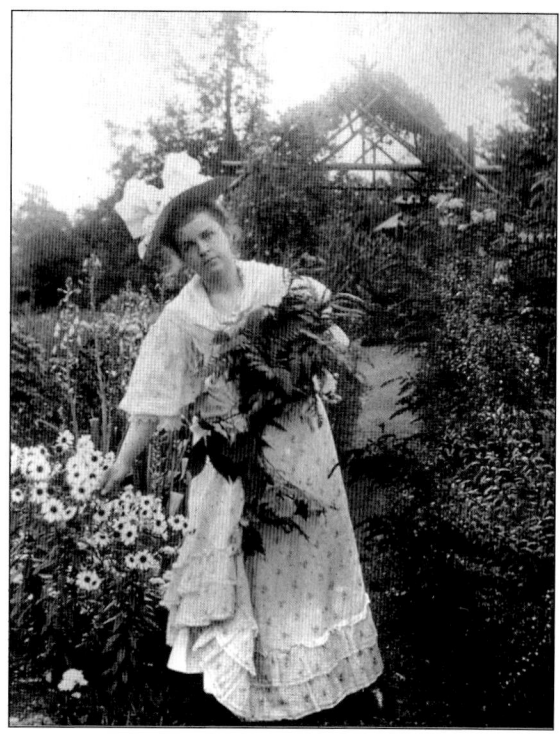

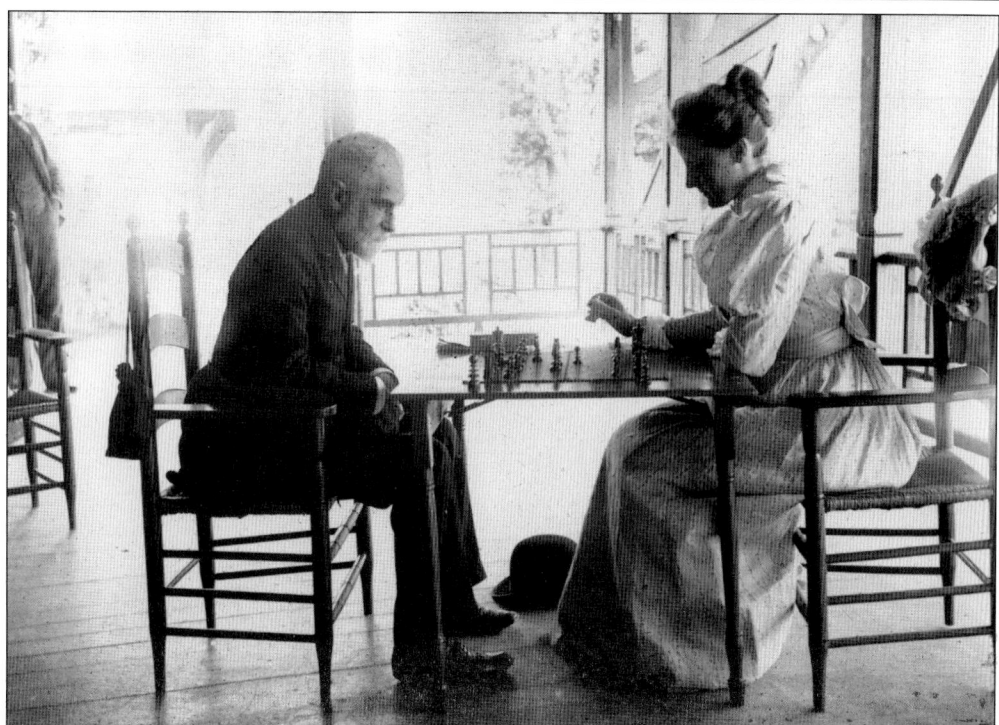

A guest contemplates her next move during an 1890s game of chess. Her partner, with a bowler hat tucked by his feet, ponders the board. They play on the veranda of the Mohonk Office Building, the predecessor of today's Parlor Wing. (Courtesy of MMHA.)

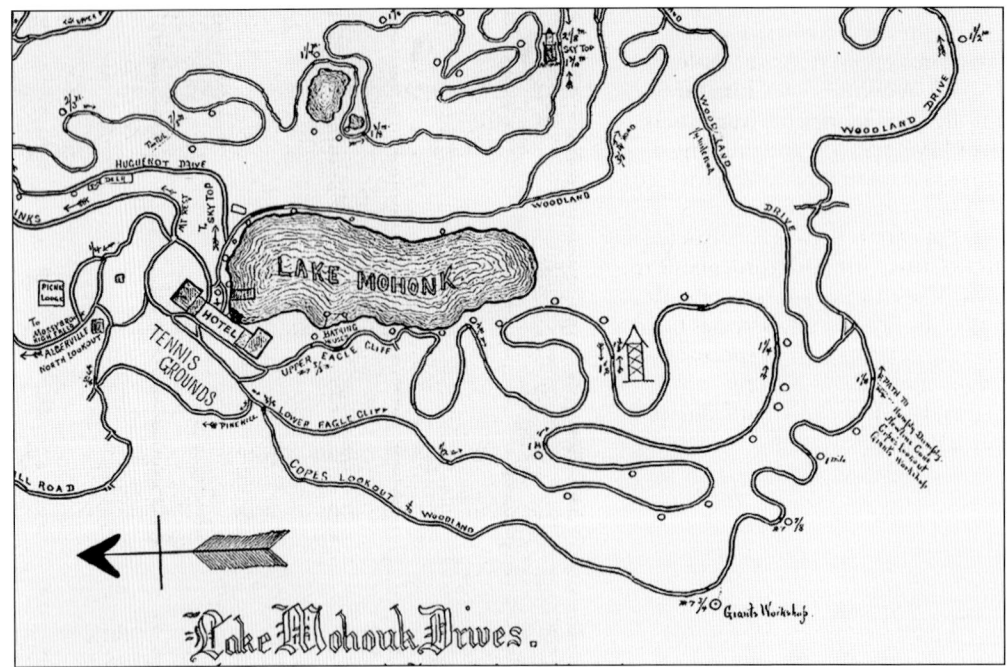

This detail of a hand-drawn map shows Lake Mohonk and surrounding carriage roads. The figure to the right of the lake, with pointed top and crosshatches, marks the site of Eagle Cliff tower, which no longer stands. A similar figure indicates Sky Top tower above the lake. The map inscription also reads, "Respectfully dedicated to Mr. A.K. Smiley and his guests by one of them. G. Frederick Brooks, July 1898." (Courtesy of MMHA.)

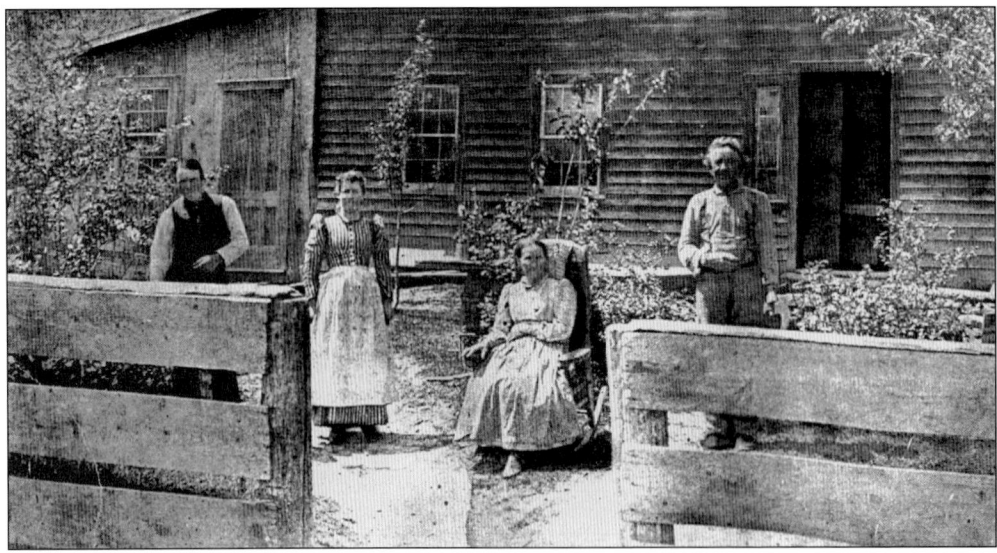

Eli Van Leuven (left) poses c. 1890 with his wife, Kathy, and his parents, Anna Marie and Hiram, at their farmstead in the Trapps hamlet. According to 1865 census records, one Trapps farm of 150 acres was valued at $1,000, with 45 acres in meadows, pasture, buckwheat, winter rye, oats, and Indian corn. Livestock included one ox, one horse, two cows, pigs, and chickens, with 200 pounds of butter produced for sale. (Property of Roger W. Van Leuven/Courtesy of MP-DSRC.)

George Enderly and a fellow quarryman pose at a local shale bank c. 1900. Workmen were hired from the area, including the Trapps and the Clove, for road and building projects at Mohonk. Shale provided an ideal surface stone for nearly 100 miles of carriage roads constructed as an extensive network throughout the area. The carriage roads were built for use by horses and carriages to provide guests access to spectacular views. (Property of Enderly descendant Joan Wustrau/Courtesy of MP-DSRC.)

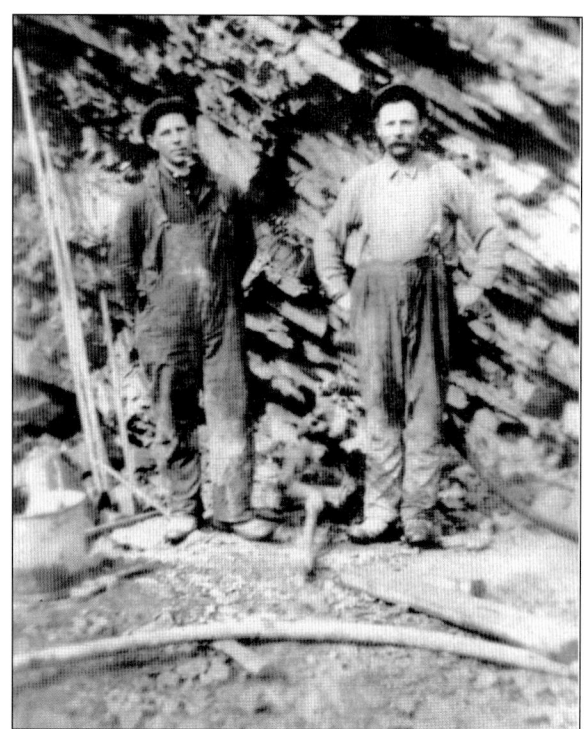

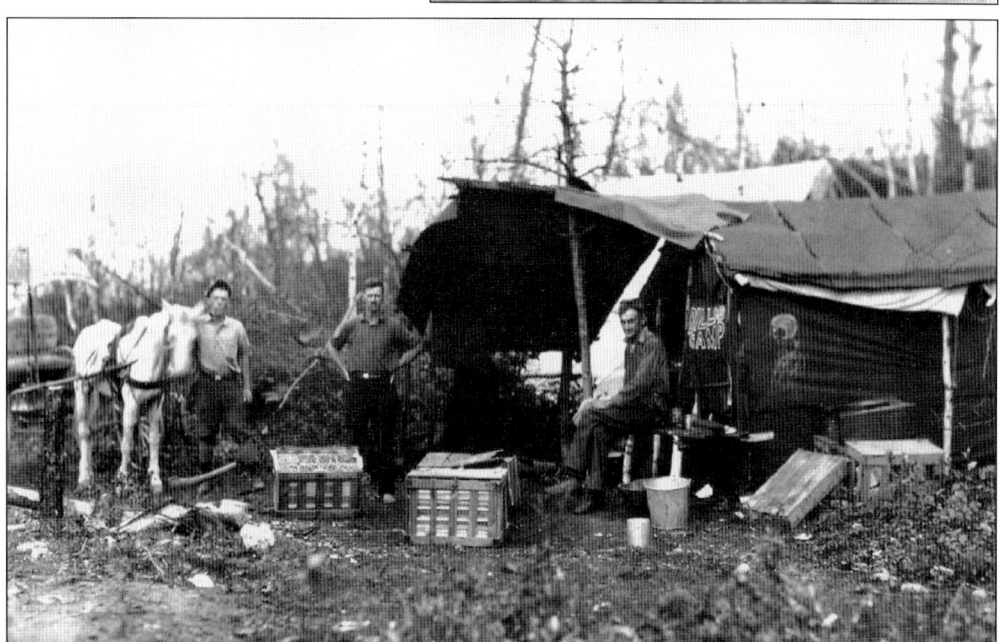

Arthur Van Leuven (left), son of Eli Van Leuven, poses with other huckleberry pickers c. 1920. The September 1895 *Ellenville Journal* reported that pickers jointly earned $50,000 from July to September. As many as 350 people summered in the Shawangunks in tents and huts of tar paper or sheet metal. One family of seven reportedly picked a record 480 quarts in one day. Pickers regularly burned the vegetation to encourage the growth of huckleberry bushes. (Property of Harold Van Leuven/Courtesy of MP-DSRC.)

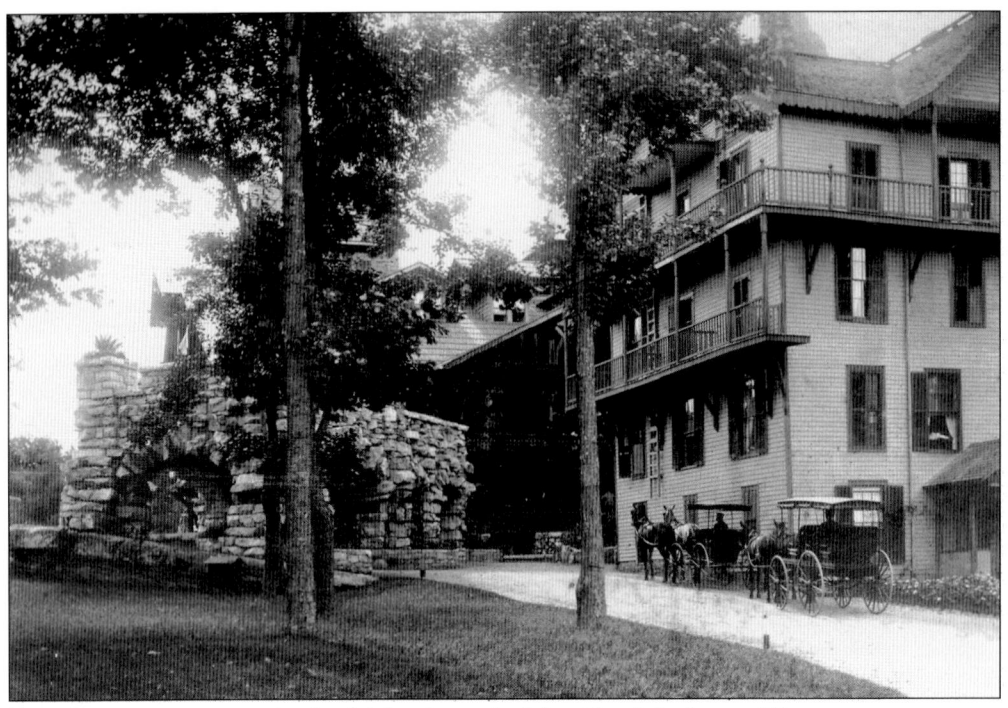

For many years, guests arrived at Mohonk on the lake side of the house. The stone porte cochere ("coach doorway" in French) on the left was built in 1899 as a grand entryway. The building on the right was demolished and replaced by a fountain between 1901 and 1902. Today, the porte cochere and the fountain remain, but the main entrance is on the opposite side of the house. (Courtesy of MMHA.)

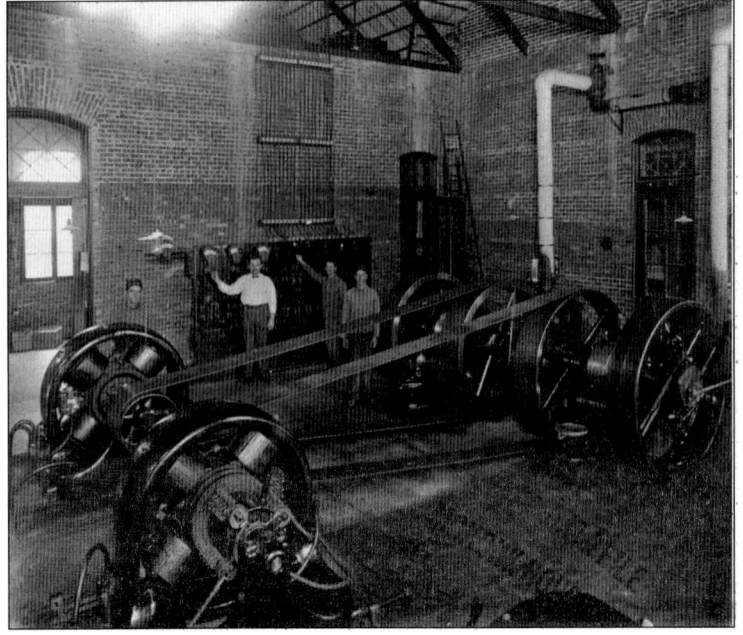

The first brick powerhouse, with generators shown inside, was completed in 1901 at the kitchen end of the Mountain House. The powerhouse enabled Mohonk to be self-sufficient in energy production. It still exists, much in its original form. The antique generators remain in running condition but are used only for demonstration today. (Courtesy of MMHA.)

Three
GROWTH IN THE NEW CENTURY: 1900–1929

Framed by the garden trellis, Albert Smiley admires a flower. Biographer Frederick E. Partington wrote of Smiley that taming the land "gave him the greatest delight of his life. He did not rest until he had coaxed into blossom nearly twenty acres of that hopeless slope of the mountain. Most of the earth was brought a mile or more—and the wonder is, still how it is ever kept in place." (Courtesy of MMHA.)

The Stone Building at the Mountain House was built in two stages in 1899 and 1902. This photograph shows the first stage of construction. The second stage replaced the wooden section on the left. (Courtesy of MMHA.)

After an intense 30-year period of building, demolition, and rebuilding, the Mountain House was completed in its current form in 1902. The oldest section still standing is the wooden one on the left, constructed in 1879. The newest section is the Stone Building in the middle. In 1986, Mohonk Mountain House was recognized as a National Historic Landmark.

Construction workers lay bricks and stone on the roof of the new Stone Building. Behind them are the Rondout Valley and the Catskills. (Courtesy of MMHA.)

The designation encompasses not only the Mountain House but also 83 other buildings on the property that are of historical significance. It also covers 7,800 acres of developed and undeveloped land, including the acreage transferred to the Mohonk Preserve. (Courtesy of MMHA.)

Viewing the grounds by horse and carriage, guests ride past the Mohonk Golf House, built in 1903 on the edge of the golf course at Mountain Rest. The golf house is one of the oldest in America. The building has been a guest rental cottage since the golf house was relocated to a larger facility nearby. (Courtesy of MMHA.)

A golfer tees off through the former apple orchard at Mountain Rest Dairy Farm c. 1900. Note the caddy in the left foreground. When the first nine holes had been laid out in 1897, parts of the pasture and much of the orchard were used. Some of the apple trees were removed as the course was developed, but the remaining trees continued to produce a crop. Currently, only two apple trees remain. (Courtesy of MMHA.)

A woman riding sidesaddle and her companion set off for a ride in 1901. Mohonk Lake and the boat wharf are to their right. The tower on Sky Top is the third one to occupy that spot; it stood from 1878 to 1909. (Courtesy of MMHA.)

Mohonk was one of the first golf courses in the nation to allow women golfers. In this c. 1900 photograph, a guest practices in the gardens near the Mountain House. (Courtesy of MMHA.)

To the amusement of guests, the Peak Sisters pose in pointed hats and starched collars for the photographer (left) in 1902. Little is known about this group, but they may have been part of a theatrical production, popular with guests and employees at the time. (Courtesy of MMHA.)

Workers dislodge massive conglomerate stone slabs for North Lookout Road, constructed in 1903. Author Bradley Snyder wrote that the extensive network of carriage roads were "built with picks, shovels, wheelbarrows, crowbars, sledge hammers, stone boats, horses, a hand-cranked derrick, and a portable boiler named Black Maria. The workmen earned room, board, and $1 per day, and [the roads were] completed at a cost of about $1 per linear foot." (Photograph courtesy of MMHA/Text courtesy of Mohonk Preserve.)

Mohonk's tradition of conferences began in 1883, four years after Albert Smiley was appointed to the federal Board of Indian Commissioners by Pres. Rutherford B. Hayes. Smiley (front row, second from right) annually hosted the Lake Mohonk Conference on International Arbitration, shown here in 1902, as well as the Lake Mohonk Conference of Friends of the Indian. Large transoms above the windows allowed cross ventilation for the comfort of attendees. (Courtesy of MMHA.)

A woman watches the construction of Undercliff Road in 1903. Called "an engineering marvel," Undercliff Road runs along the base of the Trapps cliff for over a mile. It provided a mostly level ride for carriages between Mohonk and Minnewaska. Other popular destinations c. 1900 from Mohonk included Sky Top and the Trapps cliffs. The 10-mile, three-hour round-trip to the Trapps cost $5 for a two-horse carriage and $8 for a four-horse carriage. (Courtesy of MMHA.)

Most guests had never seen deer when a small paddock was built at Mohonk in the 1880s. Overhunting and forest fragmentation had decimated their population. In 1904, a 16-acre paddock was built. In 1947, the deer were released and the paddock dismantled due to World War II shortages of repair materials and grain. The released deer, 17 in number, merged with a small wild herd. Today, their numbers are the highest ever recorded by Mohonk Preserve research staff. (Courtesy of MMHA.)

Renowned nature writer John Burroughs (1837–1921) was photographed on Sky Top in 1904. Eagle Cliff tower stands across the way. In nearby West Park on the Hudson River, Burroughs raised grapes and celery that he sold locally, including to the Mountain House, and shipped to New York City markets. Burroughs once wrote, "I am impressed afresh each time I go to Mohonk with its unique beauty. Nothing else like it in the whole country." (Courtesy of MMHA.)

Albert Smiley admires a floral arrangement in this 1904 portrait by Rockwood. Smiley was 76 years old at the time. Over the years, guests have delighted in floral arrangements from the cutting gardens and greenhouses. Smiley said that gardening gave him "a long life and abounding health." (Courtesy of MMHA.)

Mohonk's Show Gardens are pictured in this early tintype postcard. Wide paths through symmetrical beds of colorful flowers were popular around the beginning of the 20th century. These were aspects of a formal garden style called "the geometric." (Courtesy of MMHA.)

Albert Smiley (third from right) poses with the Old Boys Club at Mohonk c. 1903. The club was an informal group of male guests who vacationed regularly at the Mountain House. They played golf and planned special occasions, such as ceremonies and dedications. The members also organized and participated in boating events, including picnics on the lake, pageants, and regattas. (Courtesy of MMHA.)

Albert Smiley, as president of the board, takes the plough for the May 1907 groundbreaking of the state normal school's new site, today the oldest building at the State University of New York at New Paltz. The *Kingston Daily Freeman* reported the event, one of the biggest in the town's history. Smiley said in part, "The view from here can never be cut off; there will always be fresh air, and plenty of ground for baseball, tennis, and gardening." (Courtesy of Huguenot Historical Society.)

A crowd gathers on July 8, 1907, for the groundbreaking of the Testimonial Gateway at Mohonk. It marked the eastern entrance to the grounds along one of the original stage routes from New Paltz. Albert Smiley (right) rests a pitchfork on his shoulder. Guests and friends donated funds toward its construction to commemorate Albert and Eliza Smiley's 50th wedding anniversary. (Courtesy of MMHA.)

Albert Smiley is dwarfed by the immense stone archway of the Testimonial Gateway, dedicated in 1908. It was designed to inspire guests as they approached Mohonk from New Paltz via Lenape Lane. Once through the arch, they were greeted by the grand view of the Shawangunks and Sky Top. Construction of Lenape Lane began c. 1908 and was completed in 1925. (Courtesy of MMHA.)

Albert and Alfred Smiley pose c. 1900 in Redlands, California, where they each had a winter home. The Smileys moved there during the early years when the Mountain House was closed during the winter. Their 200-acre property, known as Cañon Crest Park or Smiley Heights, was open to the public as a botanical park until the 1930s. Today, the property has become a residential development. (Courtesy of AKSPLA.)

Ruth Smiley (standing at left) chats with Archie the chauffeur, her parents, Daniel and Effie, and her Uncle Albert in this photograph taken c. 1910. The building behind them is the Albert K. Smiley Public Library in Redlands. Albert Smiley donated the land and funds for its construction. Designed by T.R. Griffith, the library is listed on the National Register of Historic Places and is a California Historic Landmark. (Courtesy of AKSPLA.)

Albert Smiley dedicates a summerhouse to Gen. Frederick Dent Grant, son of Pres. Ulysses S. Grant, in this detail of a photograph taken in September 1912. Summerhouses were frequently named after dramatic features and special friends. According to authors Ben Matteson and Joan LaChance, the Smileys "were greatly impressed with [F.D. Grant] because he had the courage to march at the head of a temperance procession while serving as a general." (Courtesy of MMHA.)

Employees organized the Mohonk Baseball Team in 1913. Guests supported the team by paying for their uniforms and for other teams in the area to travel to Mohonk. Employees were not free to travel, as they had to tend to Mountain House guests. The team was discontinued at the end of the 1937 season. (Courtesy of MMHA.)

Guests out for a carriage ride pass a scenic overlook c. 1910. Mohonk's carriage roads were built to wind through varied terrain and designed for the element of surprise. Curved roads were a hallmark of landscape architecture of the day, found also at Central Park and many Hudson River Valley estates. To enhance the experience, trees were cut to open vistas, a 19th-century landscape style called "aesthetic forestry." (Courtesy of MMHA.)

Angeline Mac Culloch is photographed by her husband, Charles, during their honeymoon at Mohonk Mountain House. They were married in Albany on June 14, 1916. The Mac Cullochs gave a wedding gift of a honeymoon at Mohonk to their son Charles and his bride, Fran, who were married on June 16, 1942. Charles and Angeline's granddaughter, Janet Mattox, also from Albany, has worked for the Mohonk Preserve as an assistant curator of exhibits. (Courtesy of Janet Mattox.)

Five young women from the state normal school pause at the Testimonial Gateway during a walk from New Paltz to Mohonk. The Testimonial Gateway is a little more than a mile west of town. On the right is Marie K. Rente (1897–1991), who graduated in 1918. (Courtesy of Dennis O'Keefe, whose father was Marie Rente's cousin.)

Marie Rente's photograph albums document many visits to Mohonk over the years. In this photograph, a group of students from the New York State Normal School at New Paltz peer over the edge after a climb up Sky Top. The open field to their right is part of Home Farm, once the site of vineyards. (Courtesy of Dennis O'Keefe.)

Located near the Mountain House, this sawmill was built *c.* 1919 to cut lumber from the logs of dead American chestnut trees. According to *Mr. Dan's Landmark Walk*, the chestnut trees had been killed by a blight brought from Europe, which peaked at Mohonk in 1913. Wood too small for logs was cut for fuel and used at the powerhouse. (Photograph by A.K. Smiley/Courtesy of MMHA.)

Members of the Mohonk Band pose with their instruments on June 16, 1921. The band consisted of employees who played at special events. (Photograph by Harry S. Taylor/Courtesy of MMHA.)

These young women on the boat wharf cannot contain their excitement at whatever is happening outside this photograph taken c. 1920. Perhaps they are staring at a boat race or jousting contest, popular activities at the time. (Courtesy of MMHA.)

Jousters test their skill at Fourth of July festivities while guests watch from the porches of the Mountain House. Boat races and regattas were popular through the 1930s. (Photograph by E.B. Jones/Courtesy of MMHA.)

Mohonk workmen prepare to transfer rainbow trout from Duck Pond, where they were raised, to Mohonk Lake. The redwood tank was used to sort the fish, and the trout were netted out of the tank for transport. Bass were first stocked in 1875 but were not continued. Trout were introduced in 1920 and now come annually from commercial fisheries. (Courtesy of MMHA.)

Two young men screen fish at the outlet from Duck Pond. The rock wall was built in 1908 to create the pond above them. The worker at the left holds a net for screening the fish, which were put into the milk cans for transfer to Mohonk Lake. (Courtesy of MMHA.)

54

Three-year-old Daniel Smiley Sanborn (left) peers up at his grandfather Daniel Smiley, astride his favorite horse, Sunshine, in 1919. As Mohonk's proprietor, Daniel Smiley was responsible for overseeing all aspects of operation. For many years, he and Sunshine were a familiar sight riding the extensive grounds on daily inspections. (Courtesy of MMHA.)

It takes six white horses to pull a huge boiler along Garden Road in 1917 for installation at the powerhouse nearby. That year the last of the wood-burning Franklin stoves was removed from the Mountain House and replaced by steam radiators. The stone summerhouse was built in 1897 of native Shawangunk conglomerate stone and Rosendale cement. It still stands, the only one of its kind at Mohonk. (Photograph by A.K. Smiley/Courtesy of MMHA.)

Daniel Smiley's grandson Keith, 11, gingerly sets a sealed copper box in a hollow of Sky Top Tower's cornerstone, laid on August 20, 1921. Inside the box are papers about Mohonk. The derrick holding the great stone stands today in the courtyard of the Barn Museum, near the Mountain House. (Courtesy of MMHA.)

The steel framework of the cupola is raised up the face of Sky Top Tower in August 1923. Once in place, the cupola became the lookout post for fire observers from the New York State Conservation Department between 1923 and 1971. (Courtesy of MMHA.)

Carriage roads curve around to the Albert K. Smiley Memorial Tower on Sky Top, completed in 1923. The tower was funded in part by guests and friends of the Smileys. A total of 100 steps lead to a rooftop observation platform. Six states are visible on the clearest days: New York, New Jersey, Pennsylvania, Connecticut, Massachusetts, and Vermont. The adjacent reservoir was the quarry site used in part to supply the tower's stone. (Photograph by Paul C. Huth/Courtesy of MP-DSRC.)

Daniel Smiley's granddaughter Anna Smiley, 10, defies the rising water filling the new reservoir on Sky Top. Stone for the tower was quarried on the site, and the resulting pit was converted into a reservoir between 1923 and 1925. The reservoir is still used today as an additional water source for fire protection and irrigation. Anna climbed out via an unseen ladder. (Courtesy of MMHA.)

Workmen employ a portable boiler nicknamed "Black Maria" to supply steam power while repairing Huguenot Drive in February 1926. Black Maria was used for decades of road building and other construction projects at Mohonk. It provided steam power to run the drill for boring holes into the conglomerate rock. Black powder was then placed deep into the bored holes in order to blast away rock and create the roadbed. (Photograph by A.K. Smiley/Courtesy of MMHA.)

Irving Van Leuven demonstrates barrel hoop shaving at Mohonk during the 1920s. Van Leuven died in 1956, the last old-time resident of the Trapps mountain hamlet, where his family settled in the 1800s. He passed on his knowledge of rural industries while employed at Mohonk. Although the life he knew as a boy had all but disappeared, some of his neighbors lived without running water, electricity, or telephone until the 1950s. (Courtesy of MMHA.)

"Get a horse!" as the saying goes or, as in this case, a team of horses. The horses arrive to rescue a Mohonk Ford stuck in snow during the winter of 1923. The car, en route to New Paltz via Lenape Lane, slid off the road into the snowdrifts below Sky Top. (Courtesy of MMHA.)

Old-fashioned horsepower saves the day. The team of horses is backed up to the car so they can pull it out. (Courtesy of MMHA.)

A guest registers a private car at the first gatehouse at Mountain Rest. In the very early 1900s, guest automobiles were not permitted on the grounds at Mohonk in order to maintain an atmosphere of peace and quiet. Guests were chauffeured to the Mountain House after their vehicles were parked in nearby garages at Mountain Rest. This gatehouse stood until 1920. (Courtesy of MMHA.)

The 19th and 20th centuries meet at the Mountain Rest Store. It was the second gatehouse at Mountain Rest. Mohonk drivers met guests here between 1920 and 1927 for the two-mile trip to the Mountain House. The building continued as the Mountain Rest Picnic Lodge, a snack bar and souvenir shop, until c. 1955; it burned down in 1969. (Courtesy of MMHA.)

Two jumpers and a diver are captured in midair in this detail of a photograph taken at the bathing area during the early 1920s. The swimmers are students of the Mohonk School, a private school for boys located on the grounds of the Mountain House. (Courtesy of MMHA.)

Between 1925 and 1928, Mohonk Lake was lowered to create a beach and to build new summerhouses. Massive amounts of stonework were undertaken to build new piers and stone walls. Much of the work was done during the winter. When the lake was frozen, it was easier for the horses and wagons to haul the great blocks of stones to the site. (Photograph by A.K. Smiley/Courtesy of MMHA.)

John E. Vanderlyn, with handlebar moustache and bow tie, enjoys a day at Mohonk surrounded by his family in the early 1920s. For 30 years Vanderlyn owned and operated a general store in Ohioville, one of several hamlets that were eventually incorporated into nearby New Paltz. He died in 1945 at the age of 90. (Courtesy of HHHC.)

Vincent Josephson, 15, and his father, Harry, pose for his mother, Georgetta, during a vacation in the Shawangunks in August 1928. The family came from the Bronx via the Ellenville and Kingston Railroad and stayed at the foot of the mountain in a boardinghouse. The railroad, constructed after the Delaware and Hudson Canal went out of business, was completed through the Rondout Valley in 1902. (Courtesy of Robi Josephson, Vincent's daughter.)

Four
DAILY LIFE ON THE MOUNTAIN: 1930–1959

Drivers line up with their surreys at the Mountain House during the 1930s. Between 1900 and 1920, there were days when more than 400 guests were conveyed by surrey for the 5.5-mile trip from the New Paltz Depot to Mohonk. (Courtesy of MMHA.)

Two guests admire Mohonk Lake and Sky Top from their perch on Pine Bluff c. 1935. The photograph was taken by Dan Smiley, named for his grandfather and great-grandfather. Dan Smiley took thousands of photographs like this one of daily life at Mohonk, beginning in 1930. He was particularly interested in photographing activities, work projects, nature subjects, and scenery. (Courtesy of MMHA.)

Guests descend a rustic staircase during the 1930s. Many such staircases and ladders safely lead hikers through crevices and boulder fields on the grounds of the Mountain House. (Photograph by Dan Smiley/Courtesy of MMHA.)

A diver is caught in midair in this 1932 photograph. (Courtesy of MMHA.)

Young swimmers get the hang of log rolling at the bathing beach in 1932. Log-rolling contests have been part of the Fourth of July water activities for many years. After more than 50 years of service, the hemlock log was retired at the end of the summer season of 2000 and replaced by a new pine log the following year. (Courtesy of MMHA.)

Earl Stokes leads a Shorthorn bull at Brook Farm in 1934. Stokes's career at Mohonk began in 1917 as a herdsman. He lived at Brook Farm for 43 years and was head farmer there between 1944 and 1978. He worked at Mohonk until his death in 1982. (Courtesy of MMHA.)

A 1929 Ford Model A station wagon guides a caravan of hay through the gardens during the 1930s. The hay was taken along this route to the barn because the barn hill was too steep and curvy for a load of this size. The Ford was bought by A.K. Smiley and is housed today in the Barn Museum. (Photograph by Dan Smiley/Courtesy of MMHA.)

Members of the Mohonk farm crew harvest hay at Brook Farm, one of Mohonk's farms on the New Paltz side of the mountain. Hay and other grains were grown at Mohonk for feed. Straw was used for bedding in the stables, insulation for ice stored in the icehouse, and thatching for summerhouse roofs. Today, Brook Farm is leased as pastures and hayfields. (Photograph by Dan Smiley/Courtesy of MMHA.)

A Shorthorn herd heads out to pasture at Spring Farm, which was one of six Mountain House farms providing food for guests and animals, pastures for cattle and horses, and housing for pigs and chickens. Spring Farm is owned today by the Mohonk Preserve. Many of the pastures at the former farm are maintained as open space for biodiversity. (Courtesy of MMHA.)

Horses pull a load of cordwood along Oakwood Drive at -10 degrees Fahrenheit during the winter of 1934. Trees were extensively harvested over the years at Mohonk for a variety of uses, including for burning and for building projects, such as bridges, outbuildings, fences and railings, and summerhouses. This same area today, as part of the Mohonk Preserve, contains mature second-growth forest. (Photograph by Dan Smiley/Courtesy of MP-DSRC.)

Gerow Smiley takes young guests for a ride in a cart pulled by one-year-old oxen. He later became a veterinarian. He was named for Dr. S. W. Gerow, a New Paltz physician who took care of Mountain House guests from 1870 to 1897. This photograph was taken *c.* 1932 during the Mohonk Country Fair. The annual fair began in August 1918 for the benefit of the French War Relief and continued until the 1970s. (Courtesy of MMHA.)

Motorists park to admire views of the Wallkill and Hudson Valleys from the Trapps Overlook on U.S. Route 44/55 in 1932. Constructed in 1929, this was the first paved road "over the mountain." The rock-climbing cliffs in this area, once owned by the Mountain House, are today protected by the Mohonk Preserve. In 1999 roadside parking was eliminated, and the Preserve constructed safe, off-road parking nearby. (Photograph by Dan Smiley/Courtesy of MMHA.)

A group of riding enthusiasts known as the Mohonk Trail Riders explores the grounds in June 1933. The association was composed of guests who came to Mohonk twice a year from 1932 to 1942 for a weekend of riding. Lunches were cooked and served by Mohonk staff at noon halts on the trail, but Friday and Saturday nights were spent back at the Mountain House. World War II put an end to this popular activity. (Photograph by Dan Smiley/Courtesy of MMHA.)

Mohonk schoolboys hang out from the upper floors of the Mountain House. The boarding school for boys was located in the Grove Building section when the hotel was closed for the winter. Guest rooms were outfitted with bunk beds and used as dorm rooms while school was in session. Mabel Craven Smiley, wife of A.K. Smiley, founded the boarding school in 1920 for boys 10 years old to college age. (Courtesy of MMHA.)

Don Richardson supervises a class of Mohonk schoolboys studying on a Mountain House balcony during the 1930s. The school aimed "to teach boys how to study and get results from their own efforts," according to its brochures. In 1958, E.M. Lafferty and his wife bought the school and moved it to Cragsmoor and then to Wallkill, two nearby towns. The school closed in 1977. (Courtesy of MMHA.)

"A blazing fire, a winter's night and the Adventures of Sherlock Holmes" is the caption on the back of this photograph of instructor Don Eves reading to Mohonk schoolboys. (Courtesy of MMHA.)

Mohonk schoolboys build a log cabin in 1923. Remnants of several of these cabins built during the 1920s and 1930s can be found today on the grounds of Mohonk Mountain House and the Mohonk Preserve. A range of extracurricular activities was provided for the boys, including forestry, camping, mountain climbing, and outdoor sports. (Courtesy of MMHA.)

SKI SLOPE,
LAKE MOHONK MOUNTAIN HOUSE
MOHONK LAKE, N.Y.

Ruth Smiley (left) heads a line of young skiers in this 1941 photograph used as a postcard of the Mohonk Ski Slope near Mountain Rest. The ski slope used a hill that once had been part of the lower nine holes of the Mohonk Golf Course. It provided spectacular views of the Wallkill Valley, including nearby New Paltz, and operated through 1973. (Photograph by E.B. Jones/ Courtesy of MMHA.)

Leaning over in their saddles, Mohonk schoolboys reach to grab an object off the snow during a 1920s gymkhana at Mohonk. A gymkhana is a tournament of competitive games often held on horseback. The boys attending this private boarding school at the Mountain House were encouraged to participate in events of this kind as part of their extracurricular activities. (Courtesy of MMHA.)

A Mohonk schoolboy flips off a ski jump on Garden Hill, c. 1940. One of the school's aims, according to its catalog, was "to build strong, rugged health into its students." Students spent about two hours each day engaged in outdoor activities, according to Dan C. Smiley, a former student. (Courtesy of MMHA.)

Sleigh riding has long been a popular winter activity at Mohonk. Long shadows in a hemlock forest set the mood of this 1938 photograph by Dan Smiley. (Courtesy of MMHA.)

Gerow Smiley removes a bucket of sap collected from a sugar maple tree. As many as 400 trees at Mohonk were tapped during the height of production in the early 1940s. Once the syrup was bottled, it was sold in the gift shop. Tapping continued through the early 1990s. (Photograph by Dan Smiley/Courtesy of MMHA.)

Franny Smiley keeps an eye on the fire while maple sap boils in the cauldron. In the early days, many cords of wood were required to boil down thousands of gallons of sap. In later years, steam from the power plant was used. It takes many hours over a number of days for the sap to be boiled down into syrup, so the fire had to be constantly fed and tended. (Photograph by Dan Smiley/Courtesy of MMHA.)

Steam rises from a cauldron of boiling maple sap, a late winter scene at Mohonk from the 1930s until the 1970s. The cauldron was hung from a tripod of three saplings. Most of the water content of the sap must be boiled away to produce syrup; approximately 40 gallons of sap are needed to make a single gallon of syrup. (Photograph by Dan Smiley/ Courtesy of MMHA.)

Engulfed in steam, Alice Smiley removes impurities floating on top of the maple sap being boiled down into syrup. She uses a can with a flattened side to skim across the surface. The more impurities that are removed, the higher the quality of syrup. (Photograph by Dan Smiley/ Courtesy of MMHA.)

Women play lawn croquet during the 1930s. A shuffleboard court and lawn bowling green were added in the 1940s, and these three lawn games continue to be popular today. (Courtesy of MMHA.)

Guests arrive via the Lenape Lane approach to Mohonk through the Testimonial Gateway in 1932. One of the original stagecoach routes to and from New Paltz, this approach was no longer used for guests after Ulster County extended the paved road from New Paltz to Mountain Rest. In the foreground is purple loosestrife, a wildflower that became widespread in the area after it arrived from Europe with early settlers. (Photograph by E.B. Jones/ Courtesy of MMHA.)

Martin Merritt stands at one corner of the observation deck atop Sky Top Tower in 1947. The New York State Conservation Department employed forest fire observers to keep watch from the tower from 1923 to 1971. An enclosed cupola in the adjacent corner served as a sighting station for the observers. Behind Merritt is the sweep of the Rondout Valley and the Catskill Mountains. (Courtesy of MMHA.)

Clifford Persons (left) and his father, Walton S. Persons, pose in 1941 at Sky Top Tower. Clifford was on leave from the U.S. Army. Walton was a forest fire observer at Sky Top during the early 1940s. He had served for many years previously in the Catskills, as did his father before him. Walton's grandson, Paul C. Huth, is director of research at the Mohonk Preserve and works to protect part of the same lands that Walton did from Sky Top. (Courtesy of Paul C. Huth.)

New Paltz High School's Class of 1950 visits Mohonk for its senior trip, an annual tradition for many years. From left to right are the following: (front row) Hildegarde Dittman, Betty Anne Will, Alice Hernwall, homeroom teacher Fred Dippel, and Jill Miller; (middle row) Sophie Strakowski, unidentified, Ethel Ashton, Elizabeth Gibbons, and Patricia Tierney; (back row) Ruby Pomeroy and Joan Wahl. (Photograph by Gertrude Holden.)

Grounds men release fish at the boat wharf in 1950. Supervising the release are Dan Smiley (right) and Francis Smiley (rear), wearing his favorite hat. The lake was first stocked in 1871 with trout from the Rochester Fish Hatchery. At one time, stocking also included bass. The St. Lawrence skiffs had notable features: they were wider than canoes and could be paddled from either end or rowed from the middle. (Photograph by A.K. Smiley/Courtesy of MMHA.)

A winch hauls a Mohonk Jeep from the frigid waters of Mohonk Lake during the winter of 1949. The Jeep was being used to plow snow for ice-skating and ice harvesting when it broke through the ice. Dan Smiley (left) directs the Jeep's removal from a depth of 45 feet. (Photograph by Don Richardson/Courtesy of MMHA.)

Not again! A Jeep breaks through the ice during the winter of 1950. Standing on safe platforms during the removal operation, from left to right, are outside supervisor Alton Quick, Dan Smiley, and an unidentified employee. Alton Quick, known as "Quickie," began working on the grounds crew in 1919 and became supervisor in 1938. (Photograph by Don Richardson/ Courtesy of MMHA.)

Set like an aerie on the edge of Eagle Cliff, a summerhouse opens to the grand view of the Rondout Valley and Catskill Mountains. The summerhouse—Mohonk's official logo—has always been a means for guests to enjoy the scenery or a tranquil moment in nature. Summerhouses once numbered 155. Today, more than 125 still dot the grounds of the Mountain House. (Photograph by Dan Smiley/Courtesy of MMHA.)

Members of the grounds crew place thatch on a summerhouse roof in 1955. The worker in front bundles straw into sheaves. The worker on the scaffolding then fastens the sheaves into place with thin copper wire. Most summerhouse roofs at Mohonk used thatch from the 1880s until the 1960s, and a few thatched roofs were maintained into the 1980s. (Photograph by Ruth Smiley/Courtesy of MMHA.)

Between 1948 and 1964, A.K. Smiley took annual photographs of each crew as part of the personnel records. In this 1951 photograph of the outside crew, number 15 is his seven-year-old grandson, Bert Smiley, now president and chief executive officer of Mohonk Mountain House. The Smiley children who grew up on the mountain were expected to take part in Mohonk's operations. (Courtesy of MMHA.)

Warren Cruikshank (center) lands behind bars with two other inmates at the Mohonk Fair in 1957. They had to cajole passersby to pay a 25¢ "bail" to get out of jail. The Mohonk Country Fair was an old-fashioned carnival held annually in August from 1918 to the 1970s. It was similar to Fourth of July festivities, with costumes, variety shows, games, and races. (Photograph by A.K. Smiley/Courtesy of MMHA.)

81

Outside supervisor Alton Quick (left) guides a horse-drawn saw while the worker in front leads. According to Gerow Smiley, once the ice was cleared of snow and lines were marked for cutting, a saw was used to cut the ice. The single-blade saw with large teeth was similar to a plow for turning soil. When the cuts were deep enough, a spud bar was used to chop the rest of the way through. (Courtesy of MMHA.)

A power saw replaced the horse-drawn ice saw c. 1952. A gasoline engine powered a circular saw mounted on runners. The machine propelled itself as the blade bit into the ice and was considerably more efficient than previous methods used. (Courtesy of MMHA.)

From 1870 to 1964, the Mountain House annually harvested between 2,000 and 4,000 tons of ice from the lake. The harvest was started during the coldest part of the winter, when the ice was 10 inches to 18 inches thick, and took about two to three weeks to complete. (Photograph by Dan Smiley/Courtesy of MMHA.)

Workers maneuver blocks of ice with pike poles for transport to the nearby icehouse. A pike pole has a hook for pulling and a curved steel tip for pushing. Gerow Smiley remembers first using a pike pole at the age of 14 during the 1936 harvest. Once stored in the icehouse, the ice was used all year for refrigeration, for cooling drinking water, and for ice cubes. (Courtesy of MMHA.)

Billie Caron, a former manager of the Mohonk stables, examines a millstone "blank" in 1953. These unfinished stones are still found in the Northern Shawangunks at the old quarry sites. Great blocks were first broken away from the conglomerate rock by drilling holes about a foot apart, filling the holes with black powder, and igniting the powder. The blocks were then shaped into circles and finished using chisels and other hand tools. (Photograph by Ruth Smiley/ Courtesy of MMHA.)

An 18-hole putting green was built next to the Mountain House in 1898, with tournaments for men and women beginning in 1910. Ribbons were awarded weekly during the summer season, and an engraved silver loving cup was awarded at summer's end to those with the most ribbons. Scores for putting competitions, tennis matches, and shuffleboard games were reported weekly in the *Mohonk Bulletin*. The putting green is still popular with guests today. (Courtesy of MMHA.)

Five

A NEW ERA OF CONSERVATION: 1960–1989

The Mohonk Trust and the International Peace Academy of the United Nations cosponsored a United Nations Peacekeeping Seminar at Mohonk Lake in 1972. From left to right are attendees Reverend Winslow Shaw, former U.N. Secretary General U Thant (keynote speaker), Keith Smiley, and Gen. Indar Ryke. Keith and Winslow were founding members of the Mohonk Trust, later the Mohonk Preserve. The Mohonk Trust also sponsored seminars for diplomats and students during this period. (Photograph by Ruth Smiley/Courtesy of MP-DSRC.)

The "peanut stand" was the third gatehouse at Mountain Rest. It stood from 1927 to 1963, when it burned down. An outdoor parking lot was built next to it in 1958 for day visitors in an area previously used as a vegetable garden and plant nursery. (Photograph by Dan Smiley/Courtesy of MMHA.)

A new gatehouse, the fourth at Mountain Rest, was constructed in 1964. Until 1968, guest vehicles were parked in garages nearby, and guests were chauffeured to the Mountain House in hotel vehicles. Today this gatehouse is the main entrance to Mohonk. (Photograph by A.K. Smiley/Courtesy of MMHA.)

From 1963 to 1972, the Mohonk Trust sponsored annual conferences at the Mountain House for international students from American colleges. The students met to evaluate their experiences and to promote cultural understanding. Keith and Ruth Smiley hosted the conferences. Keith Smiley founded Mohonk Consultations in 1980 as an outgrowth of these discussions. (Photograph by Ruth Smiley/Courtesy of MMHA.)

Students perform native dances and songs on the last night of each year's conference. Some 90 countries were represented by students during the 10 years that the conferences were held. (Photograph by Ruth Smiley/Courtesy of MP-DSRC.)

The Smiley Fine Arts Building at the State University of New York at New Paltz was constructed during the early 1960s. Three Smiley men served as college trustees and board presidents. Albert K. Smiley served as board president from 1885 until his death in 1912; his half-brother, Daniel Smiley, from 1913 until his death in 1930; and Daniel's son, A.K. Smiley, from 1942 until his retirement in 1954. (Photograph by Robi Josephson.)

Art students from New Paltz sketch at Mohonk Lake during the early 1960s. The float at the bathing beach across the lake was added around this time. (Courtesy of Alfred H. Marks.)

Three college students from New Paltz emerge from the Lemon Squeeze at the top of the Labyrinth during the early 1960s. (Courtesy of Alfred H. Marks.)

Inching their way through the Labyrinth in September 1969 are college freshmen from New Paltz. This was one of the last years that this annual rite of passage for new students took place. The author of this book, a freshman then and somewhere in the line, made it to the top. That fall was the 100th anniversary of Albert and Alfred Smiley's arrival at Mohonk. (Photograph by John Giralico, a student counselor at the time.)

A climber leads an ascent in the Shawangunks during the 1960s. Her rope is clipped into a piton, or metal spike, that has been hammered into the crack. Through the early 1970s, piton damage increased as climbing became more popular. At that time, climbers adopted "passive protection" to help preserve the cliffs. Pitons were replaced by chocks, or metal nuts, that could simply be positioned in place. (Courtesy of MP-DSRC.)

Shawangunk stonecutter Art Coddington installs a plaque in June 1969 at Cope's Lookout. The plaque commemorates the Mohonk Trust's first gift of land—a 487-acre parcel from Mohonk Mountain House in 1966. The Mohonk Trust was established as a charitable trust in 1963; its first donation of $100 was given by Mabel C. Smiley, wife of A.K. Smiley. (Photograph by Ruth Smiley/Courtesy of MP-DSRC.)

Mohonk Preserve rangers repair the roof of Cope's Lookout Summerhouse in 1974. It is believed to be named for Edward Drinker Cope (1840–1897), a friend of the Smiley family. Cope, a paleontologist, was owner and editor of *American Naturalist*. The Smileys built Cope's Lookout Road in 1885 and the summerhouse sometime later. Today, the summerhouse is on Mohonk Preserve land but only a short walk from Mohonk Mountain House. (Courtesy of MP-DSRC.)

Dan Smiley (1907–1989), shown surveying in 1975, devoted much of each day to the study of the natural and cultural history of the Northern Shawangunks. He was a founding member of the Nature Conservancy in the early 1950s and of the Mohonk Trust in 1963, continuing as a board member when it became the Mohonk Preserve in 1978. From 1928 until his death, he filled some 15,000 index cards with thousands of detailed field observations. (Photograph by Bradley Snyder/Courtesy of MP-DSRC.)

"The part played by nature in developing a sense of values" was the first essay Keith Smiley (1910–2001) wrote as a boy. Smiley was a founding member of the Mohonk Trust; after it became the Mohonk Preserve in 1978, he continued on the board. In 1980, he founded Mohonk Consultations to promote understanding of the interrelationships of life on earth and ways to sustain earth's resources for the benefit of all life. (Photograph by Ruth Smiley/Courtesy of MMHA.)

Cross-country skiers glide along Eagle Cliff carriage road during the winter of 1977. Skiers can explore more than 35 miles of carriage roads maintained by the Mountain House and the Mohonk Preserve. (Photograph by Ruth Smiley/Courtesy of MMHA.)

Reviewing a property boundary in 1973, from left to right, are Bradley Snyder, LaVerne Thompson, and Dan Smiley. During the early days of the Mohonk Trust, Snyder and Smiley were coadministrators. When the trust became the Mohonk Preserve in 1978, Snyder was named executive director, a position he held until 1984. Thompson was a board member from 1972 to 1989. A trail at the Preserve Visitor Center is named in her honor. (Courtesy of MP-DSRC.)

Dick Williams (left) and Fritz Wiessner helped popularize the sport of rock climbing in the Shawangunks. Williams opened Rock and Snow, a recreational equipment store in New Paltz in 1970. His guidebooks to Shawangunk rock climbs are indispensable companions for climbers. Wiessner was a renowned European mountaineer who, with friends, discovered the "Gunks" for rock climbing in 1935. He and climbing partner Hans Kraus established many climbing routes here. (Courtesy of Linda Gluck.)

A foggy day provides its own unique beauty at Mohonk, as captured by Ruth Smiley in this 1987 photograph. Ruth Smiley first came to Mohonk in 1936 as a guest with her family. She married Keith Smiley two years later. She photographed Mohonk in its many moods, publishing two books of nature photographs taken on lands of the Mountain House and the Mohonk Preserve. (Courtesy of MMHA.)

Two young naturalists inch their way across a log under the watchful eye of Mohonk Preserve ranger Thom Scheuer, who, with fellow rangers, taught the earliest outdoor education classes. Preserve trustees Ruth Smiley and Marion Swinden started the program in 1972. Ann van der Meulen, the Mohonk Preserve's first educator, developed a sequential seven-year program for school groups beginning in 1985, when 1,000 students came to Mohonk. (Courtesy of MP-DSRC.)

Thom Scheuer, head ranger of the Mohonk Preserve, works a fire line at a prescribed burn in April 1979. Such burns were part of a comprehensive research effort by the Mohonk Preserve, in cooperation with the New York State Department of Environmental Conservation, to study the role and effects of fire in the Northern Shawangunk ecosystem. (Photograph by Bradley Snyder/Courtesy of MP-DSRC.)

Dr. Heinz Meng (right) of the State University of New York at New Paltz releases a juvenile captive-bred peregrine falcon at Sky Top in August 1975. Meng pioneered this work in the Northern Shawangunks and, with Cornell University researchers, released young birds from the cliffs between 1975 and 1980. These early efforts attempted to reestablish a wild population of peregrines after their precipitous decline in the 1950s due to the effects of the pesticide DDT. (Courtesy of MP-DSRC.)

Mohonk Preserve research volunteers scan the skies in October 1984 during a hawk watch at the top of the Near Trapps cliff. Dan Smiley started the hawk watches in the early 1950s. Each year volunteers make observations of migrating hawks from this summit starting in early September and continuing through November. (Photograph by Bradley Snyder/Courtesy of MP-DSRC.)

An avid rock climber since the 1950s, Thom Scheuer (left) abandoned an advertising career in New York City to become a Mohonk Preserve ranger. He was promoted to head ranger and then to director of land stewardship, a position he held until his death in 1999. He worked tirelessly over three decades of growth, while tending to thousands of climbers and visitors and safeguarding the integrity of the Shawangunks. Ranger Craig Appolito assists during a cliff-rescue training. (Courtesy of Mohonk Preserve.)

Over 10 stories up with over 10 to go, Richard Goldstone charts his next move while leading a climb at the Mohonk Preserve in 1980. The Preserve's 300-foot-high cliffs comprise an internationally known rock-climbing mecca. Thousands come annually to test their abilities on more than 500 recognized climbs at the preserve. In the distance is Sky Top Tower on Mohonk Mountain House lands. (Courtesy of Linda Gluck.)

Cadets and their instructors from the West Point Military Academy practice diving skills in front of the boat wharf at Mohonk Lake during the winter of 1987. (Photograph by Ruth Smiley/Courtesy of MMHA.)

Paul Huth (left) and Dan Smiley, Mohonk Preserve director of research, inspect vegetation along Mossy Brook in 1986. Huth started working with Smiley on research projects in 1974 and became his full-time research assistant in 1982. At Smiley's death in 1989, the Mohonk Preserve and the Smiley family transferred the responsibilities of his research legacy to Huth, who has since been the preserve's director of research. (Photograph by Gerd Ludwig/Courtesy of MP-DSRC.)

Annie O'Neill is being lowered from a climb at Bonticou Crag during the early 1980s. Bonticou Crag is a rock outcropping of Shawangunk conglomerate on lands of the Mohonk Preserve. During the 1600s, *De Bonte Koe* ("the spotted cow") was one of several Dutch ships that brought immigrants to the New World and up the Hudson River. Bontekoe later referred to a farm and then hamlet four miles north of New Paltz, originally settled in the early 1700s by the LeFevre family. (Photograph by Matthew Seaman.)

Volunteers from the rescue squads and fire departments of New Paltz (left) and High Falls (below) participate in a one-day training session at Mohonk Mountain House in June 1983. Services from the surrounding communities respond to emergency calls at the Mountain House and at the Mohonk Preserve. (Photographs by Robi Josephson.)

Six

A Continuing Commitment: 1990–Today

She's bold and beautiful. She's smart and stylish. She's Miss Piggy, shown here leading a rock climb in the Shawangunks in 1990. The Jim Henson Company arranged the publicity film shoot at the Mohonk Preserve. A Mohonk Preserve ranger (out of sight at the bottom of the cliff) has the star of the Muppets securely on belay. (Photograph by John Barrett/MISS PIGGY image courtesy of The Jim Henson Company. ™ & © The Jim Henson Company.)

Horses graze at Chapel Farm on lands of Mohonk Mountain House. The Catskill Mountains rise above the Rondout Valley beyond. Productivity at Mountain House farms peaked during the 1930s, when some 1,200 acres were farmed. Today, fewer than 500 acres are active, mostly in pasture. John F. Stokes, proprietor of Mohonk before Albert Smiley, once owned Chapel Farm. (Photograph by Robi Josephson.)

A Mohonk Preserve ranger mows a field at Spring Farm. The Mohonk Preserve maintains about 150 acres of former Mohonk Mountain House fields, which are valued for their biodiversity. Mowing season starts at the Mohonk Preserve in August, which allows field-nesting birds time to fledge their young. (Photograph by Thom Scheuer/Courtesy of Mohonk Preserve.)

Lois P. and Vincent J. Schaefer set up a fund in 1991 to provide a stipend for college students to work as interns at the Daniel Smiley Research Center of the Mohonk Preserve. Students spend 10 weeks during the summer conducting natural science research on Mohonk Preserve lands with research staff. Vincent Schaefer was an atmospheric scientist who influenced Dan Smiley to build a research center in 1980. (Courtesy of MP-DSRC.)

Mohonk Preserve staff and volunteers construct a traditional Lenape longhouse at Spring Farm in 1992. Since then, the longhouse has been used for the Mohonk Preserve's field study course in Lenape culture. Activities include storytelling, corn grinding, primitive tool use, and games of skill. (Courtesy of Mohonk Preserve.)

Ann Guenther, a Mohonk Preserve educator, crafts a traditional mat with two students. Hay and twine are used today instead of native grasses and cordage. Twine is strung in vertical strands from a frame of saplings. Hay is then woven through, using a shuttle. The Lenape placed the mats inside their homes on benches made of saplings. The mats insulated and cushioned the benches used for sitting and sleeping. (Photograph by Martha Koenig/Courtesy of Mohonk Preserve.)

Members of the Smiley family pose at Mohonk Mountain House in 1993. The children in the front row are fifth-generation family members. The Smiley family holds reunions every five years. (Courtesy of MMHA.)

Barbara Babb was hired to play a nurse in the movie *The Road to Wellville*, which was filmed at Mohonk in 1993. Her husband, Bob Babb, landed a role as a guest of Battlecreek Sanitarium. Many extras for the movie were hired from the Hudson Valley area. The New Paltz couple are long-term volunteers at the Mohonk Preserve. Bob Babb was the Mohonk Preserve's director of volunteers from 1998 to 2001. (Courtesy of Barbara and Bob Babb.)

The Mountain House was chosen as the setting for the movie *The Road to Wellville* because of its late-19th-century architecture and similarity to the Battlecreek Sanitarium in Michigan. Alan Parker wrote and directed the film, based on the novel by T. Coraghessan Boyle. The movie, shot at Mohonk and in North Carolina, starred Anthony Hopkins, Matthew Broderick, and Bridget Fonda. (Courtesy of MMHA.)

Actors posing as sanitarium guests perform rigorous outdoor exercises on the porch of the Mountain House during filming of The Road to Wellville. The scenes at Mohonk were shot during November and December 1993. The film premiered in the Hudson Valley at the Rosendale Theater near Mohonk in October 1994. Set in 1907, the movie tells the story of Dr. John Harvey Kellogg, inventor of cornflakes and founder of a famed sanitarium in Michigan. (Courtesy of MMHA.)

Bob Reid is dressed as a bellhop for his role in The Road to Wellville. He was one of the few extras hired from the Hudson Valley who traveled with the crew and cast to North Carolina to complete filming. For many years he owned Reid's Heating Service of New Paltz. When Mohonk's corporate structure changed in 1969, Reid was elected to the board of directors of Smiley Brothers Inc. and served on that board until 1996. (Courtesy of Mary Reid.)

Hosting 5,000 visits annually by area schoolchildren, the Mohonk Preserve's outdoor education program offers a variety of field studies in the Northern Shawangunks. Through cooperative efforts between the Mohonk Preserve and the New Paltz Central School District, this program was recognized in 1995 by the New York State Education Department as an integral part of that district's core science curriculum for kindergarten through grades six. (Courtesy of Mohonk Preserve.)

Hans Kraus is honored in June 1993 by the Mohonk Preserve. A plaque (left) was dedicated at the Trapps climbing cliffs to him and Fritz Wiessner. He and Wiessner pioneered many climbs in the Shawangunks and helped popularize the sport here during the 1930s and 1940s. Both are now deceased, but their legacy lives on in the climbs they established and named. (Courtesy of Mohonk Preserve.)

Thom Scheuer is cinched in a rescue litter by fellow Mohonk Preserve rangers. In a few moments, he will be lowered down the cliff several hundred feet to the ground. Preserve rangers are skilled in technical climbing and train year-round in emergency rescue. They respond to an average of 40 rescues per year. (Courtesy of MP-DSRC.)

The rescue litter, bearing a Mohonk Preserve ranger, is taken over the edge of a cliff and then lowered to the ground by rangers during a rescue-training session. (Courtesy of Mohonk Preserve.)

Curiosity turns to joy for Sunny VanDeWater as she and boyfriend Lance Edelman approach Sky Top Tower by helicopter in March 1998. Edelman arranged for the helicopter ride and for friends to hold up the sign, which reads, "Sunny, will you marry me?" Both were Mohonk employees at the time. (Photograph by Sunny VanDeWater.)

She said yes! Lance Edelman and Sunny VanDeWater celebrate their engagement after a helicopter ride over Sky Top. The couple were married in the parlor at Mohonk Mountain House on November 8, 1998. (Courtesy of Lance and Sunny Edelman.)

Vassar College roommates pose at Cope's Lookout during the senior class picnic held at Mohonk in the spring of 1919. From left to right are Alice Stoehr, Elizabeth Shackleton, Laura Williams, and Marian Lindemuth. This was Alice Stoehr's first visit to Mohonk. After graduation, she brought her mother, Ida Stoehr, to Mohonk. When Alice married Paul Schacht in 1923, the couple continued to spend their summer vacations at Mohonk and always brought her mother with them. (Courtesy of Gretchen and Charles Salt.)

Alice and Paul Schacht's daughter, Gretchen, and her husband, Charles Salt, celebrate their 50th wedding anniversary in June 1998 at Mohonk Mountain House. With them, from left to right, are Megan Salt, 12; Jeffrey Salt; Colin Salt, 7; and Janet Parker Salt. Gretchen Salt has spent vacation time at Mohonk nearly every year since 1936. The Salt grandchildren, Megan and Colin, are the fifth generation of the family to visit Mohonk. (Courtesy of Gretchen and Charles Salt.)

Bonticou Lodge, below Mountain Rest in the town of New Paltz, was the Mohonk Preserve visitor center and headquarters from 1985 to 1998 under a lease agreement with the lodge's owner, Mohonk Mountain House. A butterfly garden, funded by friends of the Mohonk Preserve, wraps around the building. Before 1985, the Mountain House provided space for the Mohonk Preserve at other buildings on its grounds. (Photograph by Bob Babb/Courtesy of Mohonk Preserve.)

During the mid-1990s, the Mohonk Preserve raised funds to build a new visitor center and headquarters on Route 44/55 in the town of Gardiner. The 9,200-square-foot visitor center contains exhibits and office space. Locally available resources and recycled material were used as much as possible during construction, and a geothermal system heats and cools the building. Nature trails and a butterfly garden were created outside. (Photograph by Thom Scheuer/Courtesy of Mohonk Preserve.)

A ribbon-cutting ceremony in May 1998 marks the opening of the Mohonk Preserve Visitor Center. Participating in the ceremony, from left to right, are Stefan Yarabek, project landscape designer; Sara Senior, Mohonk Preserve board president; Maurice Hinchey, Democratic congressman from the 26th District; Glenn Hoagland, Mohonk Preserve executive director; LeRoy Carlson, Gardiner town supervisor; and Lee H. Skolnick, project architect. (Courtesy of Mohonk Preserve.)

Volunteers join Mohonk Preserve rangers to repair erosion damage on Maple Path. The Mohonk Preserve and Mountain House annually maintain about 50 miles of footpaths through forests and fields in the Northern Shawangunks. (Courtesy of MP-DSRC.)

Volunteer bike patrollers from the Mohonk Preserve patrol Undercliff Road at the Trapps cliff area. Part of a volunteer corps of 400 people, bike patrollers educate and assist visitors about bicycling on Mohonk Preserve lands and elsewhere in the Northern Shawangunks. (Photograph by John F. Macek/ Courtesy of Mohonk Preserve.)

Frank Tkac and fellow Mohonk Preserve rangers erect a sign at the new Mohonk Preserve Visitor Center, on Route 44/55 in Gardiner. Staff from the Mohonk Preserve and Mountain House annually maintain hundreds of signs guiding visitors along an extensive network of carriage roads and trails found on the two properties. (Courtesy of MP-DSRC.)

Mohonk Preserve rangers Ed Visnovske and Hank Alicandri rebuild the bridge over the Coxing Kill in 1996. Funding for stewardship projects comes from state and local grants, as well as donations from members and supporters. (Photograph by Thom Scheuer/Courtesy of MP-DSRC.)

One of the grandest trees at Mohonk, this weeping beech spans Garden Road near the Mountain House. Guests drive under its branches on their approach to the Mountain House. The first Albert K. Smiley planted the tree in 1897. It is about 40- to 45-feet tall and 100 feet wide. (Photograph by John Van Etten.)

Guests find their way through rows of arborvitae at the grand opening of the garden maze in August 1999. The maze was constructed using 268 trees that will fill in as they mature. The rustic fence surrounding the maze is made of red cedar. (Photograph by Kimberly Traudt/ Courtesy of MMHA.)

Members of various skating clubs participate at the December 2001 dedication of the Skating Pavilion near the Mountain House. The 18,000-square-foot rink was built in part because the lake no longer freezes consistently due to a changing climate. The enclosed roof protects skaters in all weather. Under it, a framework of arched wooden beams is supported by columns of Shawangunk conglomerate stone excavated from the site. (Photograph by Kimberly Traudt.)

A couple exchange vows in the Mohonk gardens. Large-scale as well as small, intimate weddings are held at Mohonk each year in the parlor or on the grounds. (Photograph by John Van Etten.)

January 1, 1996, marks the 100th anniversary of the Mohonk Lake Cooperative Weather Station of the National Weather Service. Daily weather readings were taken for more than 50 years at the station by Dan Smiley, observer for the cooperative. Honoring the occasion, from left to right, are Daniel Keigh Smiley, Dan's oldest grandson; Paul Huth, Dan's successor as observer; and Pril Smiley, Dan's older daughter, wearing his favorite checkered wool shirt. (Photograph by Keith LaBudde/Courtesy of MP-DSRC.)

Theresa Goodlife (left), a graduate student from the State University of New York at New Paltz, works at the weather learning center located in the Mohonk Preserve Visitor Center. This interactive station was created by Terry Murray in 2000 with donated funds. It is designed for public use, as well as for use by middle and high school students, graduate students, and teachers. (Photograph by Terry Murray/Courtesy of Mohonk Preserve.)

Preserve research staff Paul Huth (left) and John Thompson watch a soaring turkey vulture from North Lookout Road in the spring of 2002. Research staff and volunteers make more than 120 field trips annually, recording over 3,000 detailed observations of plants and animals in the Northern Shawangunks. (Photograph by Veronique Dietrich/Courtesy of Mohonk Preserve.)

The Daniel Smiley Research Center houses extensive collections of specimens, research records, photographs, maps, and books, now totaling an estimated 60,000 items. Research records date back over 100 years. The center is well known throughout the region as a resource for long-term studies and for natural and cultural history information. Preserve researcher John Thompson leaves the center to conduct field studies. (Photograph by Gayle Turowski/ Courtesy of MP-DSRC.)

Eli Van Leuven's cabin was once part of the Trapps hamlet. The Mohonk Preserve acquired the cabin during the late 1960s and renovated it as an interpretive site in 2000. Through the Mohonk Preserve's efforts, the cabin and part of the original hamlet is now on the National Register of Historic Places. This is the first time a former mountain subsistence community was designated a New York State Historic District. (Courtesy of MP-DSRC.)

Hikers peer over the edge during a Shawangunk ridge hike led by Mohonk Preserve staff and volunteers. Many public programs sponsored by the Mohonk Preserve's education department have their origins with the Mohonk Mountain House and the Smiley family. Dan Smiley led weekly nature walks for guests of the Mountain House from the 1950s until the 1980s. (Photograph by John F. Macek/Courtesy of Mohonk Preserve.)

The year 1999 marks the first successful nest of the peregrine falcon in the Shawangunks since the last documented nesting attempt in 1955. Once the pesticide DDT was banned and with a determined conservation effort continuing to this day, the wild population of peregrine falcons has increased. Today, these majestic birds of prey are slowly gaining a foothold at their traditional nesting cliffs in the Shawangunks. (Photograph by Dr. Heinz Meng/Courtesy of MP-DSRC.)

Hands reach out to touch a snake during a demonstration by Roland Bahret, a herpetologist and Mohonk Preserve research associate. The children attend Camp Peregrine, one of three summer adventure camps for children offered by the Mohonk Preserve. The camps are designed for children from seven to seventeen years of age. (Photograph by Veronique Dietrich/Courtesy of Mohonk Preserve.)

Visitors from Osa, Japan, the sister city of New Paltz, climb Sky Top several days after their flight home on September 11, 2001, was canceled. They were stranded because of the Twin Towers disaster in New York City but managed to return to New Paltz. The group expressed gratitude to the Mountain House for being able to visit a place of tranquility during a time of tragedy. The people of Osa donated funds to the New York State 9/11 Relief Fund in tribute. (Courtesy of Kazuo Umeda, the mayor of Osa.)

Examining a bobcat study skin, from left to right, are Paul Huth, Mohonk Preserve's director of research; Thomas Nyquist, mayor of the village of New Paltz; and Kazuo Umeda, mayor of the village of Osa, Japan. The group from Japan, including other town dignitaries from Osa, came in April 2002 to visit Mohonk Mountain House and to see the collections at the Daniel Smiley Research Center of the Mohonk Preserve. (Photograph by Alfred H. Marks.)

In January 2002, Adam Yaple's descendants gather at the log cabin he built c. 1771. From left to right, they are as follows: (front row) Thomas Carter, Debra Carter (holding John), Emily Carter, Michael Nelson, Lawrence Yeaple, Murrelle Bishop, and Peter Yeaple; (middle row) Jean Maziarz, Judy Hespelt, Gail Yeaple, Lauren Yeaple, and Melissa Nelson; (back row) Michael Hughes, Jennifer Hughes, Don Bennett, Richard Bennett, and Amity Yeaple Dippel. Mohonk Mountain House owns and maintains the cabin today. (Photograph by Ted Reiss.)

Lands of the Mohonk Preserve are framed by the stone archway of the Albert K. Smiley Memorial Tower on Sky Top. In 1994, the Mohonk Preserve joined other private organizations, landowners, and state agencies to form the Shawangunk Ridge Biodiversity Partnership. The partners work in cooperation with Mohonk Mountain House to study and protect a natural area of over 130 square miles. Their commitment secures the long-term future of the Northern Shawangunks.

The new millennium holds great promise, as well as two noteworthy dates in its first decade. In 2003, the Mohonk Preserve marks the 40th anniversary of its founding. In 2004, the Mountain House marks the 135th anniversary of the Smiley family's arrival at Mohonk Lake. The Smileys and their successors have preserved this mountain land for the benefit of all who live and visit here. Anchored on ancient stone, their legacy of land stewardship endures. (Photograph by Paul C. Huth/Courtesy of MP-DSRC.)

Acknowledgments

I am indebted to Smiley Brothers Inc. and the Mohonk Preserve, who generously supported me during this project. I am also grateful to Carol Johnson and Marion Ryan, who gave me the idea for this book. My deepest appreciation goes to Joan LaChance, Pril Smiley, Keith LaBudde, Paul Huth, Janet Mattox, Bob Larsen, and Ted Reiss, who edited the text and helped me create an accurate and entertaining book. These individuals, as well as those listed below, shared images and information, answered endless questions, and provided guidance and encouragement throughout. This book would have been impossible without them or Pam O'Neil and the staff at Arcadia. Heartfelt thanks to all, and apologies to any whose names I have omitted.

(The abbreviations after some collections refer to how each was credited in the text.)
- Mohonk Mountain House Archives (MMHA), New Paltz, New York: Joan LaChance.
- Smiley Brothers, Inc., New Paltz, New York: Bert Smiley, Nina Smiley, Pril Smiley, Dan C. Smiley, Sandra Smiley, Gerow Smiley, Rachel Smiley Matteson, Marion Swinden, John Van Etten, Kimberly Traudt, Jim Clark, Heidi Jewett, Christina Latvatalo, and Bob Martin.
- The Daniel Smiley Research Center of the Mohonk Preserve (MP-DSRC), New Paltz, New York: Paul Huth, Bob Larsen, and John Thompson.
- The Mohonk Preserve: Glenn Hoagland, Debi Clifford, Patty Murphy, Veronique Dietrich, Kathy Ambrosini, Betty Boomer, Hank Alicandri, Frank Tkac, and Paula Weinstein.
- Haviland-Heidgerd Historical Collection (HHHC) of Elting Memorial Library, New Paltz, New York: Carol Johnson, Marion Ryan, and Linda Tantillo.
- Friends of the Shawangunks, Accord, New York: Keith LaBudde.
- The Jim Henson Company, Hollywood, California: Jill Peterson and support staff.
- Albert K. Smiley Public Library Archives (AKSPLA), Redlands, California: Larry Burgess.
- Huguenot Historical Society, New Paltz, New York: Eric Roth.
- Stone Ridge Public Library, Stone Ridge, New York: Jody Ford and Sandi Zinaman.
- Vedder Memorial Library, Greene County Historical Society, Coxsackie, New York: Shirley McGrath and Ray Beecher.
- Delaware & Hudson Canal Historical Society and Museum, High Falls, New York: Jennifer Dodd.
- Businesses: On Location, Poughkeepsie, New York; Artcraft Camera, New Paltz, New York; PDQ, New Paltz, New York.
- Attorneys-at-law: Kristen Keon Tyler, Bruce Blatchly, and Fred Rabinowe.
- Individuals: Barbara and Bob Babb; John Barrett; Elisabeth Clock; Sunny and Lance Edelman; John Giralico; Linda Gluck; Richard Goldstone; Theresa Goodlife; Ann Guenther, Gertrude Holden; Martha Koenig; John T. Kraft; Gerd Ludwig; John Macek; Alfred H. Marks; Janet Mattox; Heinz Meng; Terry Murray; Thomas Nyquist; Dennis O'Keefe; Annie O'Neill; Ed Pastusak; Sue Patterson; Mary Reid; Gretchen, Charles, Betsy, and Jeff Salt; Matthew Seaman; Bradley Snyder; John Trembly; Gayle Turowski; Kazuo Umeda; Harold Van Leuven; Roger W. Van Leuven; Norm Van Valkenburgh; Vivian Yess Wadlin; Dick Williams; Joan Wustrau; and Gail Yeaple and the Yeaple family.
- Husband and partner, Ted Reiss, who labored over and made the images beautiful; who provided love, safe harbor, and sound advice; and who made it all fun.

Selected Bibliography

Adams, Arthur Gray. *Guide to the Catskills and the Region Around*. Albuquerque, New Mexico: Sun Publishing, 1977.

Burgess, Larry E. *Daniel Smiley of Mohonk: A Naturalist's Life*. Fleischmanns, New York: Purple Mountain Press, 1996.

———. *Mohonk: Its People and Spirit, A History of One Hundred Years of Growth and Service*. 1980. Reprint, Fleischmanns, New York: Purple Mountain Press, 1996.

Evers, Alf. *Woodstock: History of an American Town*. Woodstock, New York: Overlook Press, 1987.

Fagan, Jack. *Time and the Mountain: A Guide to the Geology of the Northern Shawangunk Mountains*. New Paltz, New York: Mohonk Preserve, 1996.

Hauptman, Lawrence. *The Native Americans: A History of the First Residents of New Paltz and Environs*. Reprint, New Paltz, New York: Haviland-Heidgerd Historical Collection of the Elting Memorial Library, 1999.

Johnson, Carol, and Marion Ryan. *New Paltz*. Charleston, South Carolina: Arcadia Publishing, 2001.

Kraft, Herbert C. *The Lenape: Archaeology, History, and Ethnography*. Newark, New Jersey: New Jersey Historical Society, 1986.

Kraft, Herbert C., and John T. Kraft. *The Indians of Lenapehoking*. South Orange, New Jersey: Seton Hall University Museum, 1991.

Lang, Elizabeth, and Robert Lang. *In a Valley Fair: A History of the State University College of Education at New Paltz, N.Y.* New Paltz, New York: State University College of Education at New Paltz, 1960.

Larsen, Robert A. *Trapps Mountain Hamlet: An Interpretive Walk Through a Vanished Shawangunk Community*. New Paltz, New York: Mohonk Preserve, 1999.

Matteson, Benjamin H., and Joan A. LaChance. *The Story of Sky Top and its Four Towers*. New Paltz, New York: Mohonk Mountain House, 1998.

———. *The Summerhouses of Mohonk*. New Paltz, New York: Mohonk Mountain House, 1998.

Partington, Frederick. *The Story of Mohonk*. 1911. 4th ed. Reprint, Annandale, Virginia: Turnpike Press, 1970.

Ruttenber, E.M. *The History of Indian Tribes of Hudson's River to 1700 and 1700-1850*. Albany, New York: Munsell, 1872; Reprint, Saugerties, New York: Hope Farm Press, 1992.

Sloane, Eric. *Our Vanishing Landscape*. 1955. Reprint, New York: Ballantine, 1976.

Smiley, A. Keith. *An Anecdotal History of Mohonk*. 3rd ed. New Paltz, New York: Mohonk Mountain House, 1999.

Smiley, Daniel. *Mr. Dan's Landmark Walk*. New Paltz, New York: Mohonk Mountain House, 1989.

Smith, Philip H. *Legends of the Shawangunks*. 1887. Reprint, Fleischmanns, New York: Purple Mountain Press, 1987.

Snyder, Bradley. *The Shawangunk Mountains: A History of Nature and Man*. New Paltz, New York: Mohonk Preserve, 1981.